IMAGES
of America

AFRICAN AMERICANS IN LOS ANGELES

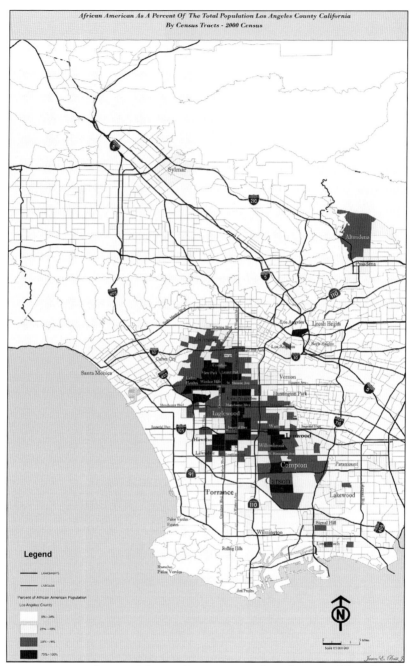

This contemporary map depicts African Americans within the city of Los Angeles and in surrounding areas. (Created by James Britt.)

ON THE COVER: In 20th-century Los Angeles, beach life was integral to many African Americans and their families. Members of the California School of Photography take a field trip to the beach on February 9, 1950. (Courtesy of the Institute for Arts and Media, Charles Williams Collection, California State University, Northridge.)

IMAGES
of America

AFRICAN AMERICANS IN LOS ANGELES

Karin L. Stanford, Ph.D.
and the Institute for Arts and Media,
California State University, Northridge

ARCADIA
PUBLISHING

Published by Arcadia Publishing
Charleston, South Carolina

Printed in the United States of America

Library of Congress Control Number: 2010921987

For all general information, please contact Arcadia Publishing:
Telephone 843-853-2070
Fax 843-853-0044
E-mail sales@arcadiapublishing.com
For customer service and orders:
Toll-Free 1-888-313-2665

Visit us on the Internet at www.arcadiapublishing.com

*This book is dedicated to my daughter, Ashley, who represents
the past, present, and future of black Los Angeles.*

CONTENTS

ACKNOWLEDGMENTS

I am truly grateful to many individuals who helped make this book possible. My deepest appreciation goes to Kent Kirkton, director of the Institute for Arts and Media at California State University, Northridge (CSUN); he provided photographs, historical insight, and staff support for this project. The center houses photographs by five African American Los Angeles photographers. Lucy Hernandez, the institute's archivist, was gracious and supportive, even as my students invaded her workplace. Gratitude is owed to Stella Theodoulou, the dean of the CSUN College of Social and Behavioral Sciences, for helping to fund this project and for her encouragement. CSUN professors Leonard Pitt and Josh Sides, both Los Angeles historians, graciously and promptly responded to my request for assistance and provided direction and recommendations. Other support came from librarian Terry Gurst at the Los Angeles Public Library and Michele Welsing and Rukshana Singh of the Southern California Library.

Several CSUN students contributed significantly. Estella Owoimaha deserves special mention for her overall support and countless hours selecting photographs, organizing pages, working with captions, and overseeing other contributors. Donnella Collison, Jonathan Watt, Todd Wilson, Carroll Brown, and Keith McElhannon selected and scanned photographs and researched important issues related to black Los Angeles.

Friends, colleagues, community activists, historians, and relatives generously shared their knowledge, talents, resources, and insights. Longtime Los Angeles residents Percy Burrell, Halvor Miller, Esq., and Larry Aubrey donated time, reviewed photographs, identified individuals, and also enhanced my sense of history. My mother, Maudestine Stanford, allowed me to rummage through her photographs. My aunt and uncle, Alna and Mel Brown Sr., presented me with their personal archives and memories of their experiences growing up in Los Angeles. My aunt, Joann Gibson, encouraged and advised me and also shared her memories. My comrades James Simmons, Rafiki Cai, and Jasmin Young provided unconditional love and intellectual support as well as their organizational and editing talents. Stephanie Jones cared for my daughter when the requirements of the book kept me away from home. Vanessa Hirsi provided me with family photographs and enthusiasm as I shared with her some of my most interesting findings. As usual, Vickie and Jerrad White gave me the time to work by creating a family for my daughter. This book would not have seen the light of day without the assertive, gracious, and competent support of my editor, Jerry Roberts. Thank you, thank you, thank you!

INTRODUCTION

People of African descent were never peripheral to the history of Los Angeles. In 1781, when Spanish governor Felipe de Neve established El Pueblo Sobre el Rio de Nuestra Señora la Reina de Los Angeles del Rio de Porciúncula, at least 26 of the first 46 settlers were considered African or a mix of Spanish and African ancestry (mulatto). During Spanish and Mexican rule, individuals of African and mulatto heritage held prominent government positions. The mulatto landowner Francisco Reyes was elected mayor during the 1790s. Pio Pico, also a mulatto, served as the last governor of California under Mexican rule, from 1845 to 1846. African descendants, like their native and Spanish counterparts, were not denied freedoms or upward mobility based on race.

In 1848, the Treaty of Guadalupe Hidalgo ended the Mexican War, ceding California to the United States. In 1850, Los Angeles was incorporated as a city. Relationships among citizens of different hues and backgrounds began to change and ultimately affected the status of African descendants in precarious ways. The Gold Rush of 1849 led to the migration of thousands of white Southerners to California. These newcomers often brought racist sentiments along with their slaves to work for them. Soon racial distinctions were implemented as the rule. As early as 1852, a law was enacted that prohibited the testimony of African Americans, Native Americans, and Chinese against whites in court. Moreover, even though California entered the union as a Free State, the legislature upheld the Fugitive Slave Act of 1793, which sent captured runaway slaves back to their owners. It was not until 1856, after Bridget "Biddy" Mason petitioned for her freedom in a Los Angeles court, that slavery was officially outlawed in California.

Prior to 1865 and the end of the Civil War, slavery limited the migration of African Americans to Los Angeles. In 1850, the first Los Angeles census showed only 12 black people registered in the city compared to 3,518 whites; however, the land boom of the 1880s and the completion of the Santa Fe Railroad to Los Angeles fueled black migration. By 1900, there were 2,131 African Americans living in the city, creating the second-largest population of African Americans in the state.

African Americans initially settled around First and Los Angeles Streets, adjacent to the rail yards. Early African American migrants worked the railroads as porters and waiters and served as domestics. Partly because of community support, but also due to real estate covenants that limited minority residence, most African Americans settled in the South Central area. At that time, South Central was integrated and shared by Mexicans, Asians, Jews, and Italians. Despite racial restrictions, opportunities for new migrants were abundant. A large number of African Americans owned their homes and established businesses. Churches were plentiful and known for uplifting the community. African American newspapers, such as the *Liberator* and *California Eagle*, had significant readerships. Organizations like the Los Angeles Men's Forum and Black Women's Clubs flourished as new migrants sought to support each other and build a strong community. The relative freedom and sense of economic opportunity were so impressive that after a visit to Los Angeles in 1913, cofounder of the National Association for the Advancement of Colored People (NAACP) W. E. B. Du Bois considered Los Angeles a place of opportunity for African Americans. In *The Crisis*, Du Bois writes, "Nowhere in the United States is the Negro so well and beautifully housed, nor the average efficiency and intelligence in the colored population so high."

By World War I, South Central had become a bustling economic and cultural center. It was home to numerous small African American professional practices and larger businesses, such as the Hotel Somerville (later the Dunbar Hotel) and the Golden State Mutual Life Insurance Company—the largest black-owned insurance company in the West. A black cultural renaissance emerged in the 1920s as African Americans pursued the arts for employment opportunities and entrepreneurship. Potential work in Los Angeles drew black musicians to the area, and nightclubs and theaters lined Central Avenue. Jazz and blues bands fostered a sense of community, and for years to come, many great entertainers—Nat King Cole, Charles Mingus, Dizzy Gillespie, and Charlie Parker—became staples of the Los Angeles arts community.

Despite the relative freedom and perceived opportunities afforded to African Americans, Jim Crow–style segregation became entrenched. African Americans were confronted with a myriad of discriminatory practices. The Ku Klux Klan was established in Los Angeles in 1921 to terrorize the black community into submission. African Americans experienced segregation at swimming pools, and many whites refused to hire them in certain high-paying industries. Charging African Americans more than whites for goods and services became commonplace—and officially sanctioned by the Shenk Rule of 1912. Named after city attorney John Shenk, it maintained that charging African Americans more than others was not extortion or a violation of civil rights.

World War II reinvigorated Los Angeles as a center of the defense and aerospace industries. Migration increased, and many African Americans arrived from Texas and Mississippi. Jobs, however, were not readily open, as unskilled white workers were hired first, and most defense plants refused to hire blacks. But, as in the past, African American leaders, elected officials, and community organizations fought against discrimination and found success.

The end of the war meant a decline in employment as factories and companies closed or relocated to the suburbs. The disappearance of jobs raised unemployment, undercut household incomes, and crippled black businesses. Central Avenue suffered as patronage at nightclubs dropped. The brutal tactics of several members of the Los Angeles Police Department (LAPD) contributed to this decline. Black businesses were intimidated, patrons were harassed, and whites were publicly warned about the dangers in African American communities. Attitudes reached a breaking point in 1965 when a scuffle between a black pedestrian and a police officer sparked an uprising in the South Central community of Watts. At the end of this six-day rebellion, 34 people were dead (31 of them black), and 1,032 were injured. Arrests numbered 3,592, and more than $40 million in property damage was tallied. The Watts Rebellion shattered any image of racial harmony or equality in Los Angeles.

The burgeoning civil rights movement in the South was also evident in postwar Los Angeles. Opposed by organizations such as the NAACP, Urban League, and Congress of Racial Equality, legal segregation and discrimination ended in education, employment, and housing. By the 1950s, African Americans began to spread southward and west, down Crenshaw Boulevard to the previously all-white areas of Leimert Park and Compton. A large percentage of the black middle class had left South Central by 1965.

Deindustrialization during the 1970s and 1980s created further economic, political, and social decline. Despite the 1973 election of Tom Bradley, the first African American mayor of Los Angeles, and the election of African Americans to the city council and state legislatures, South Central was unable to recover from the twin devastations of inadequate employment and the flight of the black middle class. Crime and gang activity were the inevitable results. In 1992, another violent uprising occurred in South Central following the acquittal of LAPD officers who had been videotaped beating Rodney King, an African American motorist. A jury in Simi Valley failed to convict the officers of excessive force. The resulting community violence left 53 dead and 2,383 injured, in addition to 7,000 fires, damage to 3,100 businesses, and nearly $1 billion in financial losses. The U.S. Army, Marines, and National Guard restored order after six days of unrest.

Despite the infamous bloodshed, many Los Angeles African Americans have benefitted from integration and black political empowerment. Affirmative action programs in city hiring, urban development, and higher education led to an increase in the black middle class. Since the 1990s, the African American community has split into middle and lower economic classes. Poverty, crime, and social isolation continue in black neighborhoods, while the drug epidemic and AIDS have ravaged the young; however, affluent blacks have been on the rise in the first decade of the 21st century, with 10 percent in Los Angeles having incomes of $100,000 or more, compared to 5.8 percent nationwide. Many African American families occupy prestigious neighborhoods, such as Ladera Heights, Baldwin Hills, View Park, and West Adams. The willingness to search for a better life—the principal idea that built Los Angeles's original black community over two centuries ago—continues anew.

One

MIGRATION AND SETTLEMENT

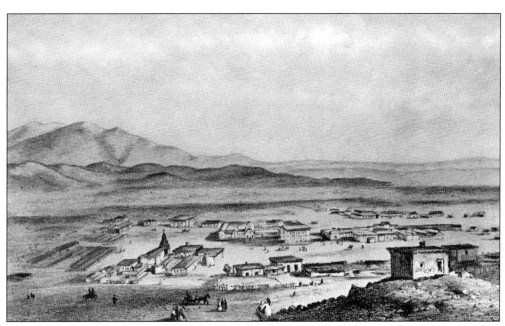

In 1781, on the orders of King Carlos III of Spain, 44 families from the Mexican provinces of Sinaloa and Sonora settled in El Pueblo Sobre el Rio de Nuestra Señora la Reina de Los Angeles del Rio de Porciúncula (The Town on the River of Our Lady the Queen of the Angels of Porciúncula). Shown here is a drawing of an early photograph of Los Angeles taken in 1850. This view is shown toward the east from Bunker Hill to the Plaza Church and beyond. (Courtesy of Los Angeles Public Library.)

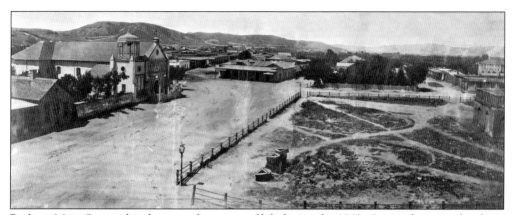

Built on Main Street, the plaza was the center of life during the 1860s. Located near multiethnic neighborhoods, it surrounded homes and other buildings and served as a public space. The Plaza Church, also featured in this image, is the oldest church in Los Angeles; it was originally called Church of Our Lady of the Angels. The original structure was damaged by a flood, and a new church was built between 1818 and 1822. (Courtesy of Los Angeles Public Library.)

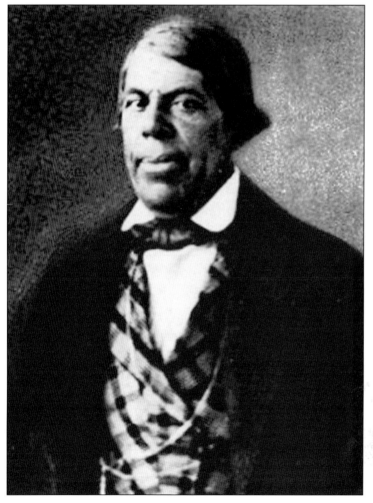

As the majority of the early settlers in Los Angeles were African or a mix of Spanish, Mexican, and/or African blood, it is no surprise that Pio Pico was of African and Mexican parentage. Pico was considered a mulatto. Born at the San Gabriel Mission in 1801, Pico served as the governor of Alta California in 1832 and then the last governor under Mexican rule from 1845 to 1846. The Pico family achieved great success in real estate and government. In 1870, Pico opened a lavish hotel near the plaza, which was well known for its fine architecture and features of modern life, including indoor plumbing. (Courtesy of Los Angeles Public Library.)

Bridget "Biddy" Mason was a slave from Mississippi who walked alongside her master's wagon to Utah and then to California. After settling in Los Angeles in 1851, Mason sued and won her freedom in 1856, six years after California became a state. As a midwife, mother, and entrepreneur, Mason became a wealthy woman, noted for her generosity and charity. She was a founding member of the African Methodist Episcopal Church in 1872, hosting its first meetings in her home on Spring Street. Mason died on January 15, 1891. A park located at 333 South Spring Street is named for Biddy Mason. (Courtesy of Power of Place: Sheila Levrant de Bretteville, Donna Graves, Dolores Hayden, Susan King, and Betye Saar.)

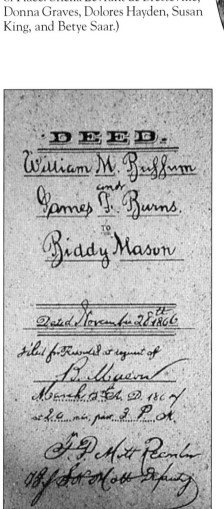

A deed to one of Biddy Mason's properties is dated November 1866. (Courtesy of Power of Place: Sheila Levrant de Bretteville, Donna Graves, Dolores Hayden, and Betye Saar.)

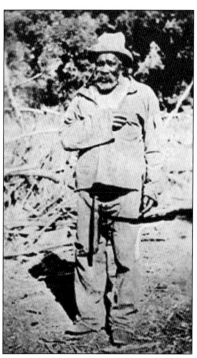

Pioneer John Ballard, a former slave from Kentucky, won his freedom in 1859 then moved to California and settled in Agoura Hills, near the Santa Monica Mountains. The blacksmith and trader was a founding member of the First African Methodist Episcopal Church and very involved in civic affairs. The area of Ballard's residence became popularly known as Niggerhead Mountain, later Negrohead Mountain, referencing Ballard as well as the growing black population and a 2,031-foot volcanic peak. The racial slur was used on early government topographic maps of the Santa Monica Mountains. Ballard died in 1905 around the age of 75. (Courtesy of J. H. Russell.)

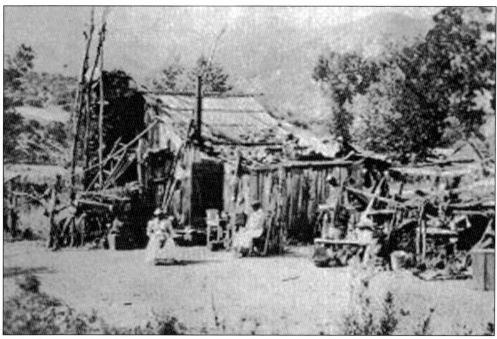

In the book *Heads and Tails . . . and Odds and Ends*, J. H. Russell, who had grown up in Agoura and visited Ballard's cabin, wrote in 1963, "The Ballard house was something to behold. It was built of willow poles, rocks, mud and Babcock Buggy signs ('Best on Earth'), Maier and Zobelein Lager Beer signs and any other kind of sign the old man picked up. Hardly a Sunday passed where there were not several buggies, spring wagons and loads of people going down the canyon to see the place." (Courtesy of J. H. Russell.)

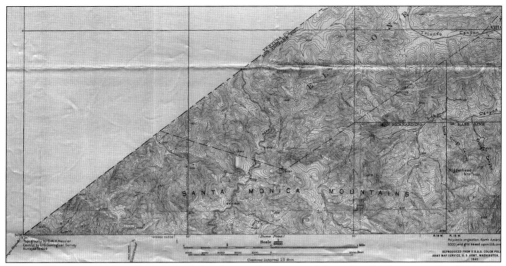

Pictured here is a 1932 edition of a federal map designating Niggerhead Mountain. In 1964, the U.S. Geological Survey's Board on Geographic Names changed all such names to Negro. In 2009, the U.S. Geological Survey officially changed the name to Ballard Mountain after the Los Angeles County Board of Supervisors response to the requests of several residents. (Courtesy of U.S. Geological Survey. Russel Valley (map). Scale 1:20,000: Washington, D.C., 1932. Item held in digital format in California State University, Chico Memorial Library Special Collections, Chico, California.)

During the Mexican era, Calle de los Negros (referred to as Nigger Alley) was an area of town inhabited by those of darker hue, including Chinese, Mexicans, Native Americans, and African Americans. Also known for its violence, saloons, gambling, and prostitution, Nigger Alley was the location of the Chinese Massacre in which anti-Chinese sentiment led to the murder of 18 people of Chinese heritage. Originally Calle de los Negros formed the homes of Mexican rancheros and was the area where immigrants settled during and after the California Gold Rush. The street was eventually named Los Angeles Street. (Courtesy of Los Angeles Public Library.)

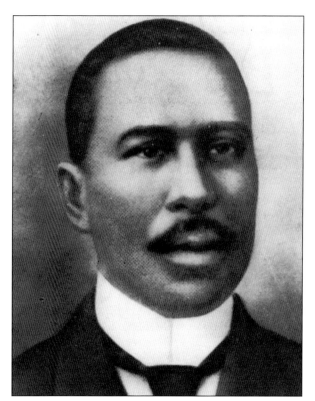

In 1879 or 1892, John J. Neimore established the oldest African American newspaper in Los Angeles. First named the *Owl*, and later the *Eagle*, Neimore's paper helped newly arrived African Americans settle in Los Angeles by regularly publishing information about housing, jobs, and other news relevant to their community. (Courtesy of Southern California Library.)

Charlotta Bass was the editor of the *Eagle*, which later became the *California Eagle*, for close to 40 years. After relocating to Los Angeles for health reasons from Providence, Rhode Island, the former Charlotta Spears took a job with John J. Neimore. (Charlotta married Joseph Bass in August 1914.) Bass sold subscriptions until she became editor of the newspaper after Neimore's death in 1912. The eventual owner and editor of the *California Eagle*, Bass also served as a leader of many civil rights organizations and ran as the vice-presidential candidate on the Progressive Party ticket in 1952. (Courtesy of Southern California Library.)

Frederick Madison Roberts (1880–1952), the great grandson of Thomas Jefferson and Sally Hemings, was born in Harris-Station, Ohio, in 1879. His parents, Andrew Jackson Roberts and Ellen Wayles Hemings, moved to Los Angeles when Frederick was six years old. Roberts was the first African American graduate of Los Angeles High School and attended the University of Southern California. Destined for politics, Roberts owned *New Age* magazine, which he used to denounce racism and support African American progress. Roberts ran for the Los Angeles School Board in 1911 with the slogan "Justice for All" but lost. He won a seat in the California State Assembly in 1918, making him the first African American to serve in that legislative body, from 1919 to 1933. Many of his initiatives were aimed at eliminating racial discrimination. (Courtesy of African American Museum and Library, Oakland.)

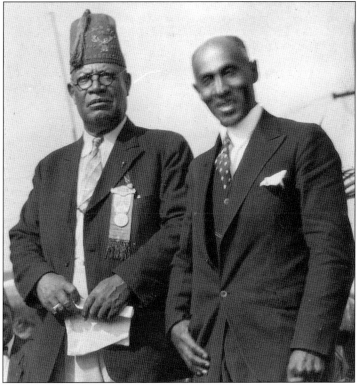

Joseph Blackburn Bass (left), editor-in-chief of the *California Eagle* and husband of Charlotta Bass, was a newspaper editor from Kansas who moved to Los Angeles in 1911. He married Charlotta Spears in 1914 and worked as the editor of the *Eagle* until his death in 1934. He is seen here with Frederick Madison Roberts, the first African American elected to the California State Assembly. The men appear to be attending a convention during the 1920s, as Bass is wearing a fez and a medallion. (Courtesy of Southern California Library.)

Col. Leon Washington was the founder and publisher of the *Los Angeles Sentinel* newspaper. After moving from Kansas to California in 1930, Washington was employed by the *California Eagle*. His political activism extended beyond journalism. He instituted a campaign with the slogan "Don't spend your money where you can't work," urging blacks to avoid businesses that refused to hire them. This is a photograph of Leon Washington with his godchild, Jane Marie Miller, in 1933. (Courtesy of Halvor Miller, Esq.)

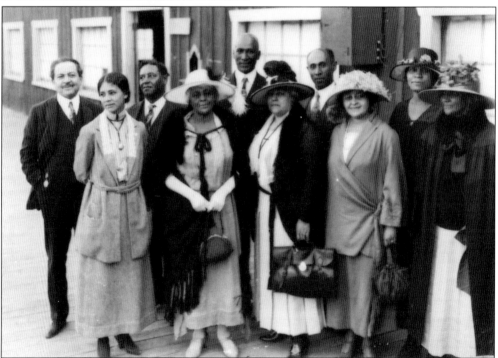

The Los Angeles Chapter of the NAACP was chartered in 1914, after the visit of W. E. B. Du Bois to Los Angeles. African American dentist John A. Somerville and his wife, Vada, hosted Du Bois and became members. Attorney E. Burton Ceruti was elected executive secretary of the branch. This photograph depicts the executive board in 1923 at the groundbreaking ceremony of the Dunbar Hotel. The NAACP led legal battles against discrimination and restrictions in housing, employment, and education. (Courtesy of Los Angeles Public Library).

From left to right, Jimmie, Suzie, and Ida Jackson highlight beach fashions at the Ink Well, a portion of Santa Monica Beach, in 1922. Ida Jackson, the mother of famed civil rights attorney Halvor Miller, was born in 1904 in the former Oklahoma Territory. She came to Los Angeles with her family at the age of two. (Courtesy of Halvor Miller, Esq.)

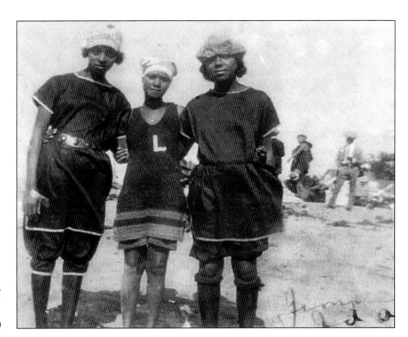

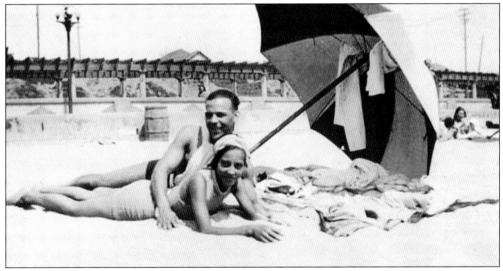

Verna Williams and her friend Sidney relax at Santa Monica Beach. The segregated beach was one of the few places where African Americans could spread their blankets on the sand in 1920. Rules were on a sign labeled "Negroes Only." African Americans were only allowed space on a 200-square-foot area of the beach known as the Ink Well, located at the foot of Pico Boulevard. Racial restrictions were invalidated in 1927. On February 7, 2007, the City of Santa Monica unveiled a memorial plaque in honor of Nicolas Gabaldon, the first documented African American surfer, and the Ink Well Beach. (Courtesy of Shades of L.A. Archives/Los Angeles Public Library.)

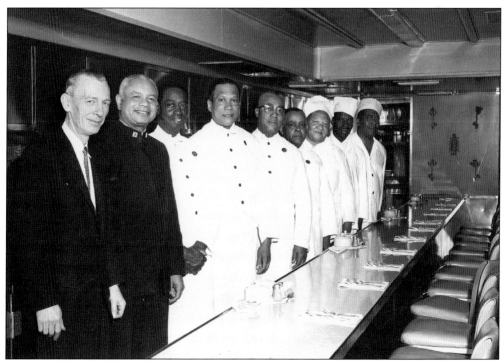

This photograph features several African American cooks and waiters standing in the dining car of a train. Also in the kitchen area, counters and seats were provided for passengers to relax and eat while traveling to their destinations. The waiters are dressed in formal service attire. The fourth waiter from right is Lemaud James Nash Sr. (Courtesy of Launa Jean Nash.)

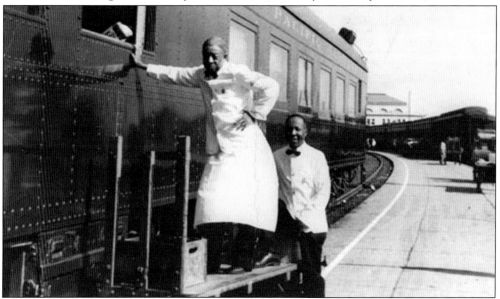

Charles McKinney (left) and Frank Carter were waiters on the Southern Pacific Railroad. Railroad workers were very important to the black community. They brought income and news about important events affecting African Americans nationwide. This photograph was taken at Union Station around 1945. (Courtesy of Los Angeles Public Library.)

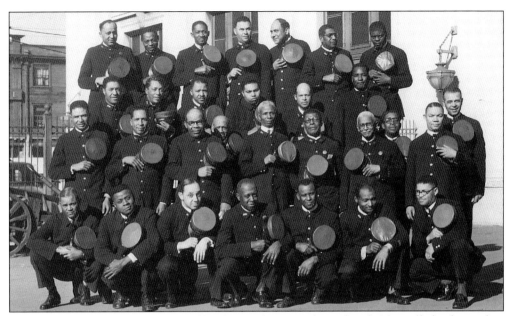

These railroad porters were employed by the Southern Pacific Railroad. Also called redcaps, they assisted passengers and handled baggage. African American porters played an important role in recruiting African Americans to Los Angeles. They spread the word about the benefits of Southern California. Porters also distributed African American newspapers along their routes. If these men were employed in 1925 or later, they likely joined the Brotherhood of Sleeping Car Porters, founded by A. Philip Randolph to fight discrimination against African American workers. This image was taken in the 1920s at Central Station in downtown Los Angeles. Central Station was abandoned in 1939 when Union Station opened. (Courtesy of Southern California Library.)

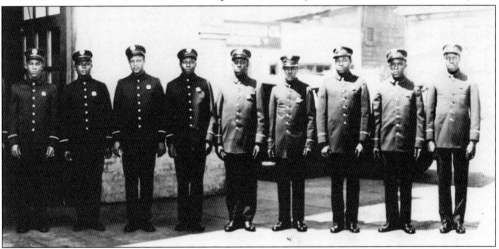

When George W. Bright was hired as a firefighter on October 2, 1897, the fire department had been officially segregated for only two years. The rules prohibited African Americans from eating or fraternizing with other firefighters and using station dishware. One rule required that African American firefighters stand "four human spaces away from the other firemen during line ups and inspections." As a result of the antidiscrimination efforts of African American firefighters, Mayor C. Norris Paulson ordered the fire chief to integrate its ranks in 1955. This photograph was taken in 1910. (Courtesy of the Los Angeles Public Library.)

This family photograph, given as a Mother's Day gift, includes, from left to right, Edna Wilkins-Brunson, Bessie Wilkins-Nash, John Wilkins Jr., Lucille Doris Wilkins-Paley, and Mary Wilkins-Person. The family migrated to Los Angeles from Natchez, Mississippi, in the 1930s. (Courtesy of Launa Jean Nash.)

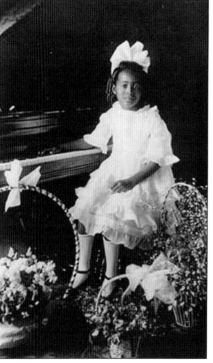

Flowers surround Juanita Terry at age seven as she sits at the piano for her recital on June 3, 1919. Her clothes, headdress, and piano lessons reflect her middle class status. (Courtesy of Shades of L.A. Archives/Los Angeles Public Library.)

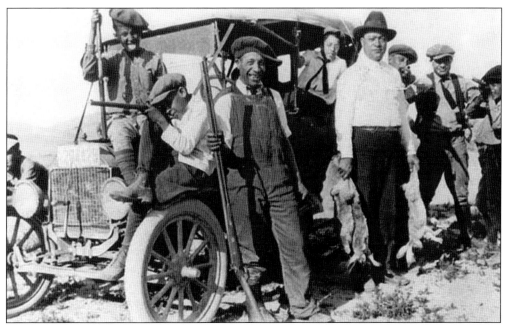

As it was in the South, hunting was a way to put food on the table in California. These men and boys show off their rifles and shotguns, along with the rabbits they bagged about a mile north of Los Angeles in Rosamond in 1922. (Courtesy of Shades of L.A. Archives/Los Angeles Public Library.)

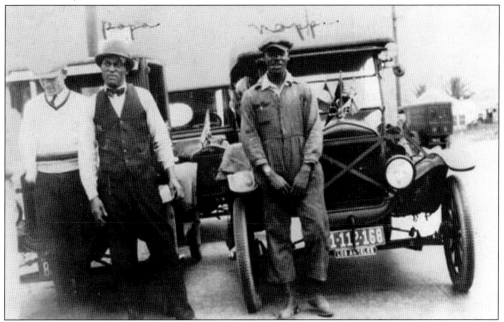

Representing his business interests, Jule L. Deckard (center, wearing vest) is standing in front of several cars with a friend (right) in 1924. Deckard was the owner of an auto repair business called the Guaranteed Service Automotive Company, located on Central Avenue. Deckard moved his family from Texas after suffering severe racism and an attempted lynching. (Courtesy of Shades of L.A. Archives/ Los Angeles Public Library.)

From 1906 to 1909, African American William Joseph Seymour's Azusa Street Revival became an important center of the Pentecostal movement. The Baptist pastor migrated to Los Angeles in 1906 from Texas, although he was born in Louisiana. In April 1906, Seymour held his first service on Azusa Street. He preached a message of holiness and salvation to an integrated audience, while parishioners spoke in tongues, became healed, and had otherworldly visions. On April 18, 1906, the *Los Angeles Times* reported on the controversial meetings. Headlined "Weird Babel of Tongues," the *Times* article states that "the devotees of the weird doctrine practice the most fanatical rites, preach the wildest theories and work themselves into a state of mad excitement in their peculiar zeal." Seymour's revival is credited with the formation of other Pentecostal denominations. (Courtesy of Stanley M. Burgess and Gary B. McGee. *Dictionary of Pentecostal and Charismatic Movements*. Regency Reference Library.)

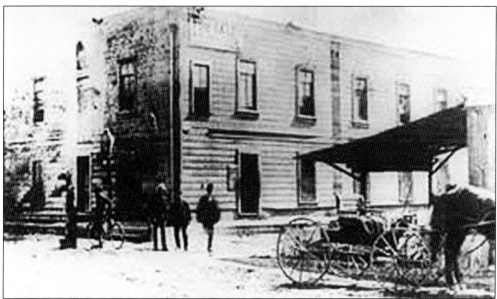

This is a photograph of the Apostolic Faith Mission located at 312 Azusa Street in Los Angeles and presided over by William J. Seymour. Services at the shabby, two-story wooden building ran continuously, day and night. (Courtesy of . Stanley M. Burgess and Gary B. McGee. *Dictionary of Pentecostal and Charismatic Movements*. Regency Reference Library.)

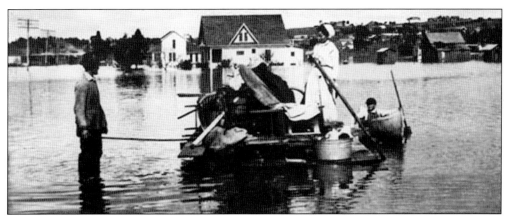

An African American woman is seen on a homemade raft containing household goods in a flooded area of the city. Although the image is not dated, the deluge shown here most likely occurred in 1938, when Riverside, Orange, and Los Angeles Counties experienced devastating floods from the Los Angeles, San Gabriel, and Santa Ana Rivers and their tributaries. That year, abnormal and constant rainfall occurred from February 27 through March 1. (Courtesy of Los Angeles Public Library.)

This photograph of African Americans at a social function in the 1940s appeared in the *California Eagle*. They are, from left to right, (first row) Mrs. Taylor, Alweeda Williams, and Willie May Beavers; (second row) David Williams (who later became the first African American judge appointed to the U.S. District Court in Los Angeles), Mrs. Bradford, H. Claude Hudson (founder of Broadway Federal Savings and former president of the Los Angeles branch of the NAACP), George Beavers (one of the founders of Golden State Mutual Insurance Company), and Dr. Taylor, a physician who owned the Taylor Medical Building. (Courtesy of Southern California Library.)

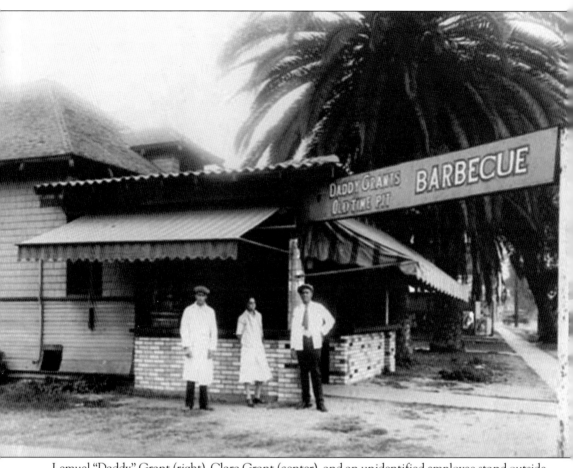

Lemuel "Daddy" Grant (right), Clara Grant (center), and an unidentified employee stand outside of Daddy Grant's Oldtime Pit Barbecue on Washington Boulevard around 1930. Daddy Grant's restaurant was very popular during this period and was visited by African Americans of all economic classes. (Courtesy of Shades of L.A. Archives/Los Angeles Public Library.)

Two

BUILDING COMMUNITY

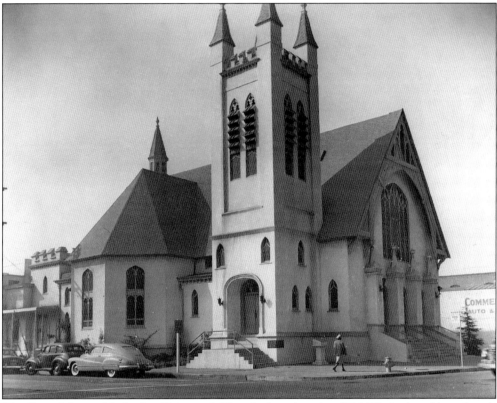

The First African Methodist Episcopal Church, Los Angeles (FAME), is the oldest church established by African Americans in the City of Angels. The AME Church is a Methodist denomination founded in 1816 by Bishop Richard Allen in the city of Philadelphia. With more than 19,000 members and several dozen ministries within 13 corporations, FAME is one of the largest churches in Southern California. At its founding, the church was located in Biddy Mason's home. After several church relocations, Rev. Jarrett E. Edwards commissioned a new home for the congregation in 1901, with the style of the architecture he had seen on a trip to England. The photograph shows the church site at Eighth Street and South Towne Avenue before it was relocated in 1969 to its current place in the Sugar Hill section of Los Angeles, at 2270 South Harvard Street. On January 6, 1971, the Eighth Street and Towne Avenue location was declared Los Angeles Historical Monument No. 71. (Courtesy of Los Angeles Public Library.)

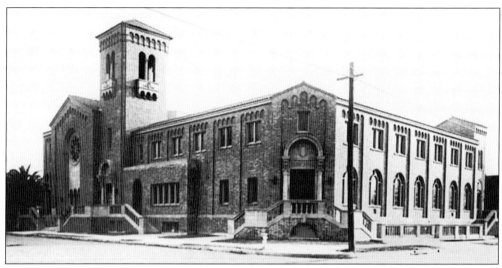

The Second Baptist Church, located at 2412 Griffith Avenue, was the second African American church in Los Angeles. Along with the Twenty-eighth Street YMCA, the church was among the first nonresidential projects in the black community. The structure was built in 1924 by the famous African American architect Paul R. Williams. (Courtesy of Los Angeles Public Library.)

This elegant and regal trio of housekeepers includes Adlena Billops Woodfin (left) with her two coworkers. This photograph was taken at a mansion in Beverly Hills during the 1930s. (Courtesy of James Key.)

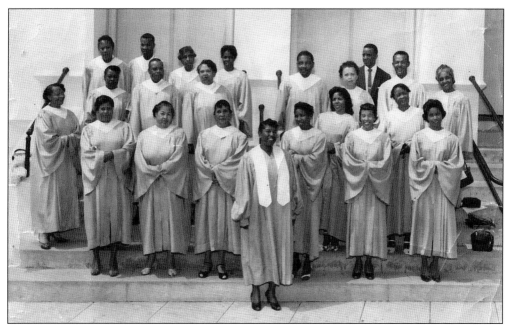

Church choirs serve as an important source of spiritual and religious worship in the African American community. They also preserve the memory and history of the African American experience through their lyrics and style. Pictured here are the church choirs of the First African Methodist Episcopal Church (above) and a youth choir of Hamilton Methodist Church (below) during the post–World War II era. Many of the greatest singers in rhythm and blues and jazz started out in the youth gospel choirs of black churches, such as the one below. (Above, courtesy of Alna Brown; below, courtesy of the Institute for Arts and Media, Harry Adams Collection, CSUN.)

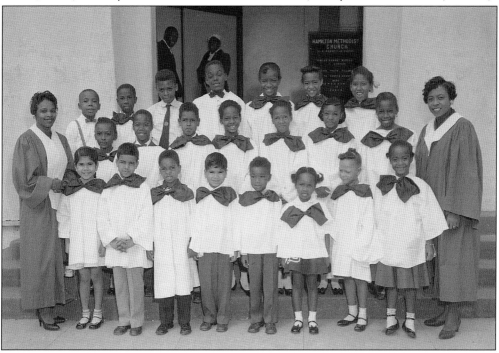

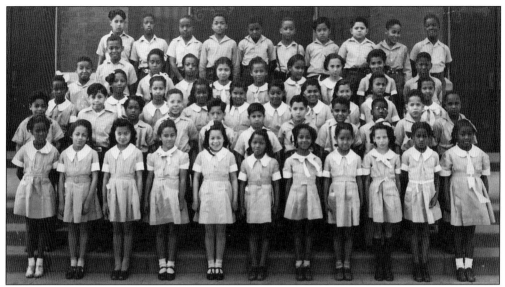

St. Patrick Elementary School is located at the intersection of Central Avenue and Jefferson Boulevard in the heart of South Los Angeles. This image features third and fourth grade classes in 1944. The school was predominately African American for much of its existence but diversified along with the community. Percy Burrell, later an accomplished musician, is in the top row, fifth from the left. He played with some of the most noted entertainers of his time, including Marvin Gaye, Lou Rawls, Chubby Checker, and Errol Grant. (Courtesy of Percy Burrell.)

Children at Twentieth Street School are featured in a performance during their celebration of May Day 1948. The children are of various ethnicities and backgrounds reflective of the racial composition of South Los Angeles during that time. The tradition of May Day dates back to the pre-Christian era in Europe. It is associated with the coming of spring or the completion of half the year. (Courtesy of the Institute for Arts and Media, Charles Williams Collection, CSUN.)

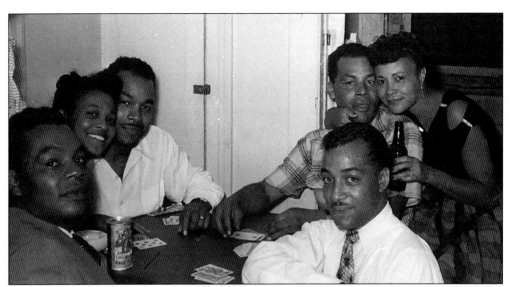

An extended family socializes around a card table. Mel Brown (third from left) and his brothers Clark, Vincent, and Russell migrated from Akron, Ohio, in the late 1920s. Like most African Americans in the North, the Browns had Southern roots, as their mother, Vicki (far right), hailed from LaGrange, Georgia. The family lived near the intersection of Adams Boulevard and Western Avenue. (Courtesy of Mel Brown Jr.)

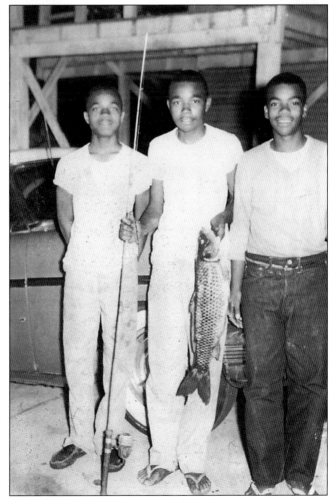

Mel Brown Jr. (center), age 12, along with Richard Brown (left), age 10, and Clarke Bumpy Brown (right), age 9, went fishing at Echo Park in Los Angeles. Mel Jr. caught a carp weighing about 12 pounds. He later became an avid fisherman and caught a 125-pound marlin in 1987. Born in Los Angeles in 1941 at General Hospital, Mel Brown Jr. lived with his family at 132 North Mountain View Avenue. (Courtesy of Mel Brown Jr.)

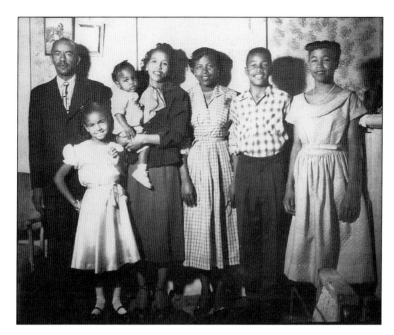

Members of the Hunt family, originally from Alligator, Mississippi, migrated to Los Angeles in 1945. They were part of the Great Migration, when African Americans moved from the South to northern cities and California. (Courtesy of Andrea and Hebron T. Hunt Jr.)

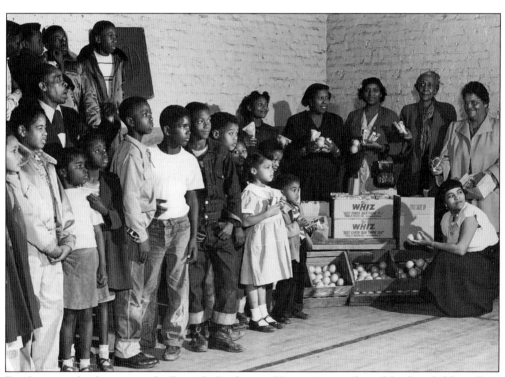

Employees and volunteers at the Eastside Settlement House give candy and food to children. Exie Lee Hampton, executive director of the house, stands at far right. This image was published in the *California Eagle*. Writing on the back of the photograph states that three of the women are "Mesdames Crutchfield, Garland and Wini Orr," but it does not specify who these women are or identify the other two women. (Courtesy of Southern California Library.)

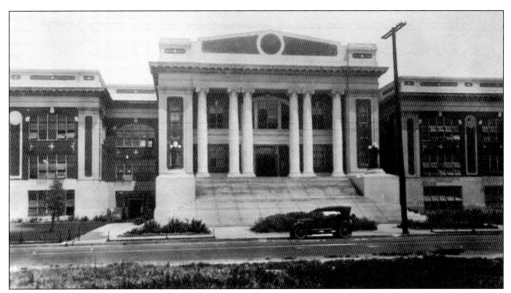

At Forty-first Street and Hooper Avenue, Jefferson High School was one of few schools open to African Americans in early Los Angeles. Founded in 1916, it is the fourth-oldest public high school in the Los Angeles Unified School District. During the 1920s, it served students from all racial backgrounds, but as more African Americans migrated to the city, the school became majority black. Notable alumni include Dr. Ralph Bunche, Rep. Augustus Hawkings, athlete and actor Woody Strode, Horace Tapscott, singer Etta James, and choreographer Alvin Ailey. (Courtesy of Los Angeles Public Library.)

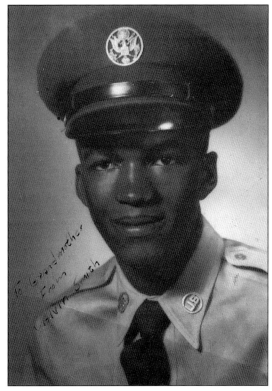

Calvin Smith joined the air force in 1954 after attending Jefferson High School. He served in Cheyenne, Wyoming, before his transfer to Wiesbaden, Germany. Discharged in 1958, he moved back to Los Angeles. This photograph was given to his grandmother, Minnie Smith. (Courtesy of Beverly Porter.)

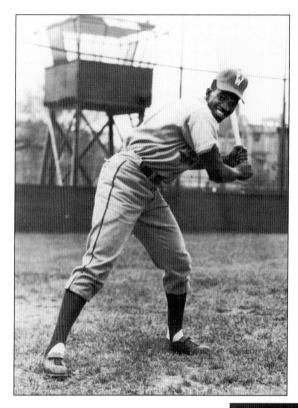

While serving in the air force, Calvin Smith was lucky enough to have caught the tail end of what was known as "special services." In addition to his regular job, he was able to play both baseball and basketball, which afforded him numerous opportunities for travel, including to Spain and various European cities. (Courtesy of Beverly Porter.)

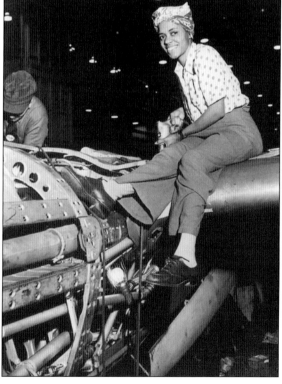

World War II brought industry and jobs to Los Angeles. Thousands of African Americans migrated to Los Angeles to work in defense plants. Here a female worker poses with the airplane she is helping to build. The photographer's caption reads, "Rosie the Riverter was a popular song during WWII. She really did work on the planes and other high priority items. Women who had never worked at any job, or any job like this, became anxious to help their husbands, brothers and sons get home sooner." This woman was a resident at Rodger Young Village. (Courtesy of Los Angeles Public Library.)

Located at 4227 South Central Avenue, the Dunbar Hotel was built in 1928. Originally known as the Hotel Somerville, it was the focal point of the African American community in Los Angeles during the 1930s and 1940s. The Somerville was named after its builder, John Somerville, a dentist who led the campaign to build the hotel in order to host the NAACP convention. The elegance and popularity of the hotel attracted jazz greats such as Cab Calloway, Billie Holiday, Count Basie, Lena Horne, and Duke Ellington, who performed and stayed at the hotel. This photograph was taken on April 23, 1987, after the hotel had been closed for several decades. The Dunbar is no longer a hotel but contains 73 low-income apartments. (Courtesy of Los Angeles Public Library.)

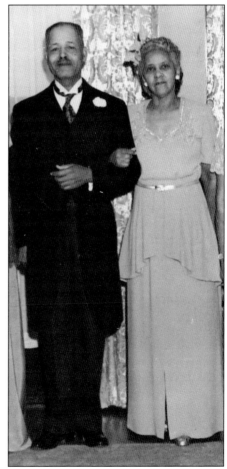

John A. Somerville and his wife, Vada, pose in formal attire. The couple graduated from the University of Southern California's School of Dentistry and practiced in Los Angeles. In 1914, the Los Angeles branch of the NAACP was organized at a meeting in their home. Somerville built Hotel Somerville at 4225 Central Avenue in 1928; the following year, the building was renamed the Dunbar Hotel. Somerville also served on the Los Angeles City Police Commission. (Courtesy of Southern California Library.)

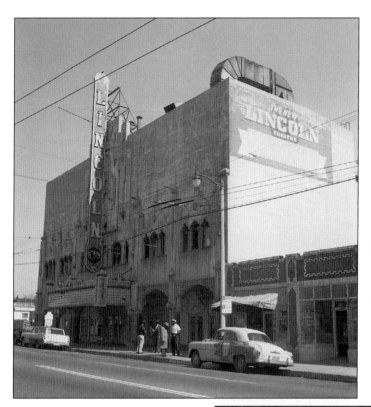

Referred to as the West Coast Apollo, the Lincoln Theatre hosted musical shows, movies, live dancing, and other entertainment. Opened in 1926, the theater at 2300 South Central Avenue, seen here in October 1961, was the largest and most popular venue on that famous street. The Lincoln Theatre was declared Los Angeles Historic-Cultural Monument No. 744 in 2003. (Courtesy of the Institute for Arts and Media, Harry Adams Collection, CSUN.)

Actress and singer Dorothy Dandridge (first row, second from right) stands among beauty contestants in 1946. Dandridge moved from Cleveland, Ohio, to Hollywood seeking success in the entertainment industry. She starred in acclaimed films including *Carmen Jones* and *Porgy and Bess*. In 1954, she became the first African American actress to earn an Academy Award nomination for Best Actress for her role in *Carmen Jones*. (Courtesy of Shades of L.A. Archives/Courtesy of Los Angeles Public Library.)

On their wedding day in Los Angeles, Hattie McDaniel and her husband, Lloyd Crawford, stand handsomely attired. McDaniel was one of the best-known African American actresses of her era. The first African American to win an Oscar for acting, she won a Best Supporting Actress award for her portrayal of Mammy in *Gone with the Wind* (1939). (Courtesy of Southern California Library.)

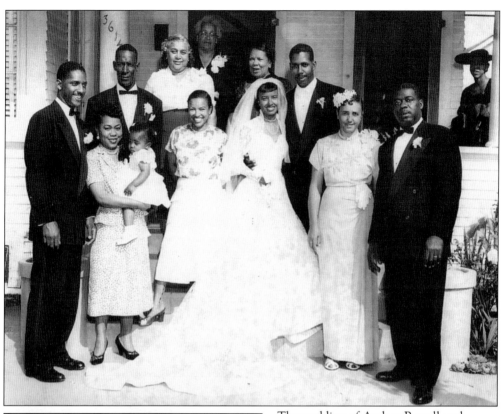

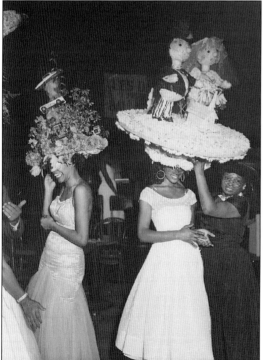

The wedding of Audrey Burrell and Herman Reed was at St. Patrick's Church in 1953. Here the bride and groom pose with family members after the service at the home of the Burrell family at 3614 Adair Street. As seen from the attire of the bride and groom, the wedding was lavish. (Courtesy of Percy Burrell.)

The history of African American women sporting fashionable hats is evident in this image. Social clubs for African American women were very popular in Los Angeles during the mid-20th century (here, November 1954). Clubs with a tradition of African American women wearing decorative hats were turned into contests and used as fund-raising events for charity. The hat on the right displays a wedding scene including a bride and groom and little wedding chapel. The other hat presents a city scene detailed with cars, one house, and stacked hills. (Courtesy of the Institute for Arts and Media, Harry Adams Collection, CSUN.)

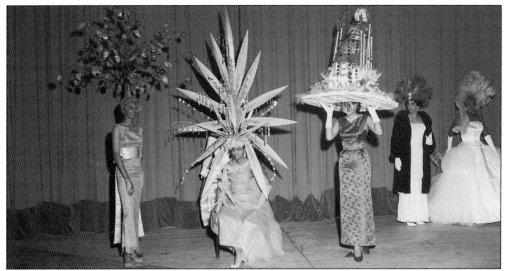

The history of the black elite in Los Angeles began later than similar social stratification in other cities with large black populations, such as Washington, D.C., Atlanta, Detroit, Chicago, and New York. However, African American women in Los Angeles were equal to women's groups in other cities with regard to fund-raising for charity. Featured here are women from a social club posing with their decorative hats before a show in June 1962. (Courtesy of the Institute for Arts and Media, Harry Adams Collection, CSUN.)

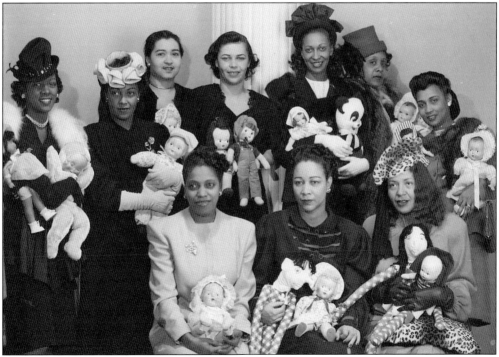

This photograph of the Doll League in Los Angeles features members holding their dolls and stuffed animals sometime between 1941 and 1950. Dolls portraying babies of African descent were rare during this period, as were dolls of other races and ethnicities. (Courtesy of Southern California Library.)

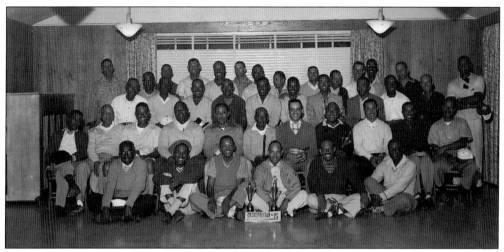

This photograph features golfers who were involved with the Cosmopolitan Golf Club's 12th Invitational Golf Tournament at the Fox Hills Golf Course. Founded during the 1940s, Cosmopolitan was one of the first black golf clubs in the country, providing opportunities for blacks to become professionals. This photograph was taken on July 1 or 2, 1956. (Courtesy of the Institute for Arts and Media, Harry Adams Collection, CSUN.)

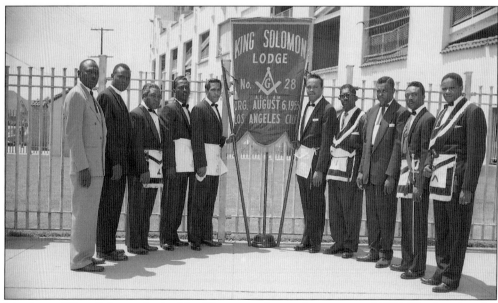

Members of King Solomon Lodge No. 28 are seen during the summer of 1956. The Los Angeles branch is part of the national fraternal organization of Freemasons. The fraternity is administratively organized into Grand Lodges. This photograph indicates that this lodge was established on August 6, 1955. (Courtesy of the Institute for Arts and Media, Harry Adams Collection, CSUN.)

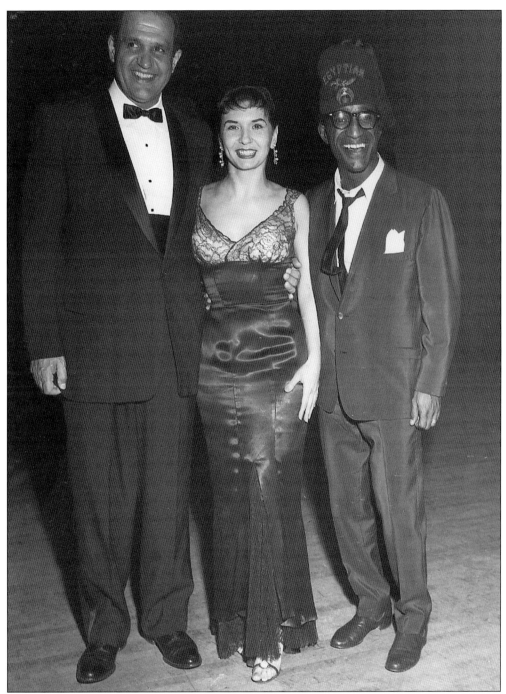

Sammy Davis Jr. (right), shown here with Alan King (left) and an unidentified woman, was a multitalented performer, starting at an early age as a vaudeville tap dancer. Davis eventually became a major star on Broadway, in movies, and on television as well as a headliner in Las Vegas. He was a member of the notorious Rat Pack with Frank Sinatra, Dean Martin, and others. Davis died in Beverly Hills, California, on May 16, 1990. (Courtesy of the Institute for Arts and Media, Harry Adams Collection, CSUN.)

In 1883, Sweet Daddy Grace was born Charles Emmanuel Grace in Cape Verde, off the coast of West Africa. He immigrated to the United States in the early 1900s and learned from Pentecostal and Evangelic ministers. He founded the United House of Prayer for All People, and word of his charismatic ministry led to its expansion to Brooklyn, Charlotte, Los Angeles, and abroad. Grace eventually acquired the fondly used name "Sweet Daddy Grace." His parishioners were expected to attend service daily. The congregation would take an hour "coming to the mountain" by singing, clapping, speaking in tongues, and feeling the spirit. Claims by fervent followers that Grace healed people resulted in exorbitant offerings and wealth. While the United House of Prayer was located on Vernon Avenue, Grace owned a hotel on Adams Boulevard. He died in 1960 in his 85-room Los Angeles mansion. (Courtesy of the Institute for Arts and Media, Charles Williams Collection, CSUN.)

Three

THE BLACK METROPOLIS

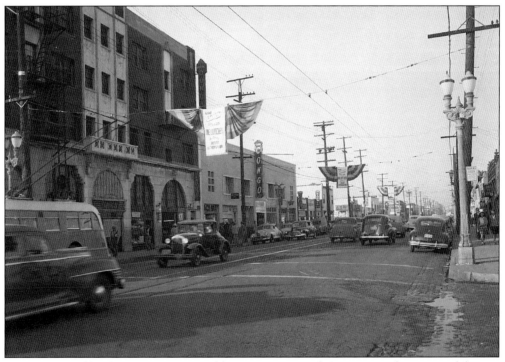

As the home of black entertainment and businesses, Central Avenue was the center of the Los Angeles African American community from the 1920s to the 1950s. The avenue was known for its theaters, nightclubs, and professional offices. The West Coast version of the Harlem Renaissance occurred there as jazz bands were formed and musicians from throughout the United States traveled to the area to perform. (Courtesy of the Institute for Arts and Media, Charles Williams Collection, CSUN.)

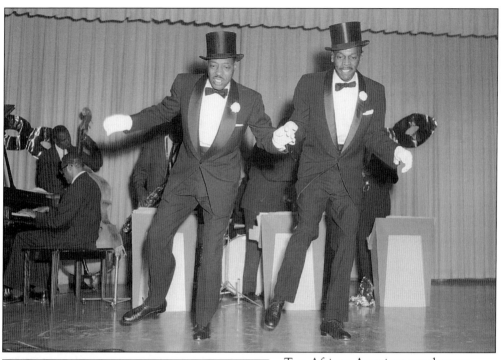

Two African American tap dancers are seen on January 21, 1957. Although influenced by many cultures, tap dancing was developed and popularized in African American communities as a way to maintain the percussive sound in music. (Courtesy of the Institute for Arts and Media, Harry Adams Collection, CSUN.)

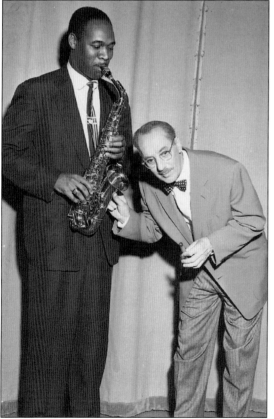

Buddy Collette (left) and Groucho Marx perform on stage in June 1954. William Marcel Collette was born in Los Angeles on August 6, 1921. He played tenor saxophone, clarinet, and flute, and his bebop sounds were heard on Central Avenue and as a studio musician. In the early 1950s, Collette was the first African American musician to perform on television, on Marx's program *You Bet Your Life*. Collette was also noted for his efforts to desegregate the musicians union of Los Angeles and his organization of a rally protesting government repression of the political activist Paul Robeson. (Courtesy of the Institute for Arts and Media, Harry Adams Collection, CSUN.)

Seen here is Roy Milton performing at the Congo, a club located on Central Avenue, in June 1948. A native of Oklahoma, Milton moved to Los Angeles in 1933. The singer and drummer formed a band, performed in local clubs, and established his own record label. He recorded several top 10 hits, including "Hop, Skip and Jump" (number three on the R&B charts in 1948), "Information Blues" (number two, R&B, 1950), and "Best Wishes" (number two, R&B, 1952). (Courtesy of the Institute for Arts and Media, Charles Williams Collection, CSUN.)

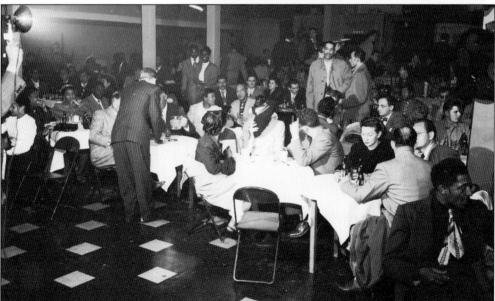

Located on Central Avenue, Jack's Basket Room was an after-hours club and gathering place for the "Black Bourgeoisie" and top entertainers. Owned by Jack Johnson, the first African American heavyweight boxing champion, the Basket was host to music, dancing, and even gambling from 2:00 a.m. until daybreak. (Courtesy of the Institute for Arts and Media, Charles Williams Collection, CSUN.)

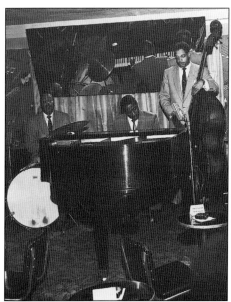

Born on June 15, 1921, Errol Garner was one of the most popular jazz musicians of the 1950s. The self-taught pianist moved to Los Angeles from Pennsylvania. Garner's gift for music and melody led to his recordings of several popular songs, including the pop hit "Misty," which became a hit for five different artists between 1959 and 1975. In 1971, Garner rerecorded "Misty" for Clint Eastwood's feature directorial debut, *Play Misty for Me*. Garner formed his own band and performed throughout Europe. (Courtesy of the Institute for Arts and Media, Harry Adams Collection, CSUN.)

Extravagant dress was the norm for nightclub entertainers. The intricately designed yet uniform dresses for these beautiful women posing during September 1955 demonstrates the style worn by entertainers and guests on Central Avenue. (Courtesy of the Institute for Arts and Media, Harry Adams Collection, CSUN.)

In the midst of these suited gentlemen is Louis Cole (second from left), a well-known musician who performed on Central Avenue. The clothes on the other men in this 1956 picture reflect the flashy nightclub scene at the time. (Courtesy of the Institute for Arts and Media, Harry Adams Collection, CSUN.)

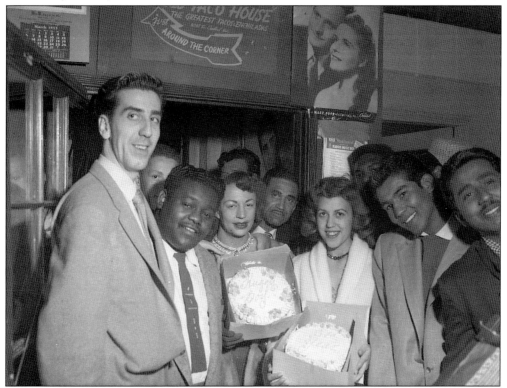

Dick "Huggy Boy" Hugg is pictured at a nightclub with Fats Domino in 1955. The radio disc jockey and television host was instrumental in the promotion of rock and roll in the 1950s—especially Chicano bands. Domino, a pianist and songwriter from New Orleans, was apparently visiting Los Angeles. (Courtesy of the Institute for Arts and Media, Harry Adams Collection, CSUN.)

At age 37, Jersey Joe Walcott became the oldest man to win the world's heavyweight boxing title. This photograph was taken in November 1955 in Los Angeles, the year before the boxing drama *The Harder They Fall* was released. Walcott costarred in the film with Humphrey Bogart and Max Baer. (Courtesy of the Institute for Arts and Media, Harry Adams Collection, CSUN.)

In May 1956, world champion boxer Sugar Ray Robinson speaks with another boxer, Art Aragon, known as "Golden Boy." Born in Detroit in 1921, Walker Smith became known as Ray Robinson after borrowing an amateur card from a friend with the same name. He was called "Sugar" because of his stylish dress and athletic grace. Robinson moved to Los Angeles, California, where he spent many of his remaining years as an actor and where he also founded the Sugar Ray Robinson Youth Foundation. (Courtesy of the Institute for Arts and Media, Harry Adams Collection, CSUN.)

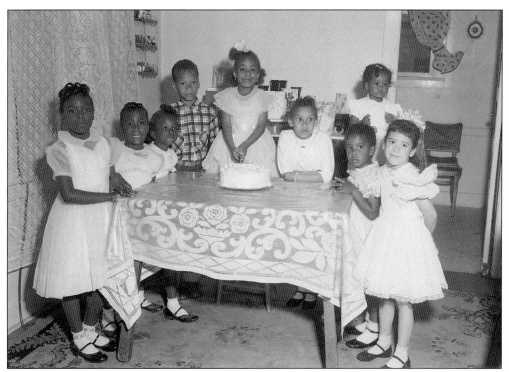

The photographs on this page depict children at birthday parties in 1954. That same year, the U.S. Supreme Court's unanimous decision in *Brown v. Board of Education* effectively desegregated public institutions in the United States. After the ruling, schools that had barred African American students were opened to all students, allowing them broader access to better educational opportunities. (Both, courtesy of the Institute for Arts and Media, Harry Adams Collection, CSUN.)

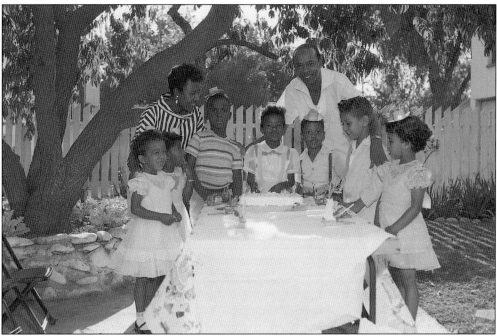

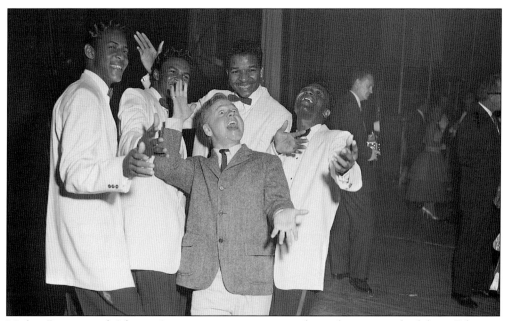

Mickey Rooney and African American musicians enjoy themselves at a nightclub on February 17, 1958. The background suggests that the musicians are attending a predominantly white event. Despite segregation, it was not uncommon for Hollywood entertainers to take a progressive orientation toward race relations and refuse to abide by segregation laws. (Courtesy of the Institute for Arts and Media, Harry Adams Collection, CSUN.)

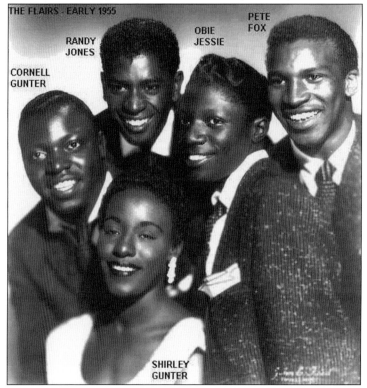

The Flairs, a doo-wop group based in Los Angeles, had several singles during the 1950s, beginning with "I Had a Love." Some members left to work with other doo-wop groups. (Courtesy of Beverly Porter.)

Service jobs located in South Central Los Angeles were abundant, but also competitive, as local people were able to earn a decent wage close to their homes. Workers at a gas station are depicted here on May 19, 1955. Filling station workers during this period could easily be identified by their uniforms. (Courtesy of the Institute for Arts and Media, Harry Adams Collection, CSUN.)

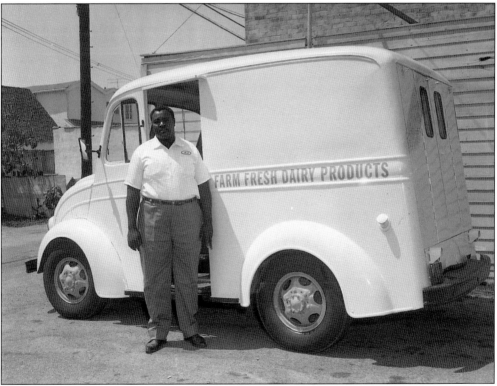

Inadequate refrigeration meant that dairy products could easily spoil; therefore, it was common for many African American families to contract with a company to deliver fresh milk and other dairy products to their homes. Here is a photograph of an unidentified milkman with his truck. (Courtesy of the Institute for Arts and Media, Harry Adams Collection, CSUN.)

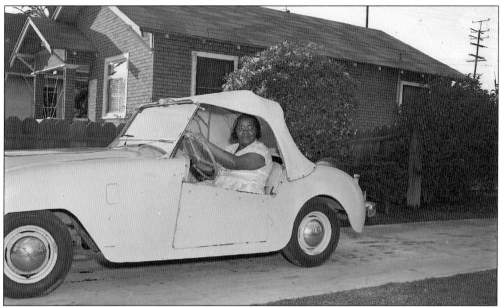

A woman sits in a model of the short-lived sports car, the Crosley Hotshot, in June 1954. The car was famous for its low price but criticized for its slowness and engine trouble. It was sold in automobile dealerships and in appliance stores, as its creator was a manufacturer of radios and refrigerators. The vehicles, first sold in 1939, were no longer available for purchase after 1952. (Courtesy of the Institute for Arts and Media, Harry Adams Collection, CSUN.)

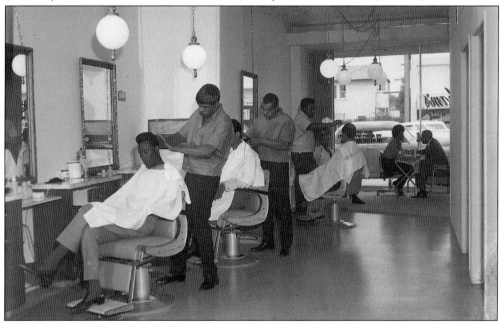

The barbershop was, and is, an epicenter for news, gossip, philosophical debate, and entertainment in the community. Harry Adams, a noted photographer, owned this popular barbershop located on Central Avenue. Hairstyles among men during this period consisted of naturals and permanents, also called conks. This photograph was taken by Adams in September 1964. (Courtesy of the Institute for Arts and Media, Harry Adams Collection, CSUN.)

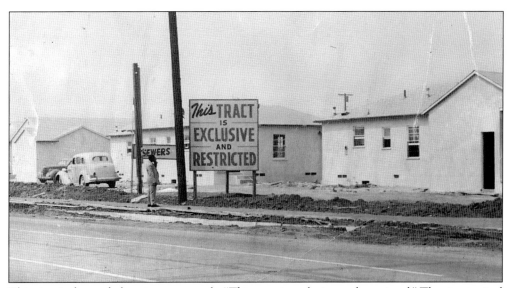

This sign in front of a housing tract reads, "*This* tract is exclusive and restricted." The sign invited white veterans to apply for housing from builders of the Sunkist Gardens project in Southeast Los Angeles. African American veterans who applied were told that the development was for "white veterans only." Racism existed in the Los Angeles housing market, where many properties had restrictive covenants that barred African Americans and other minorities from buying or renting homes. This photograph was published in the *California Eagle* on September 28, 1950. (Courtesy of Southern California Library.)

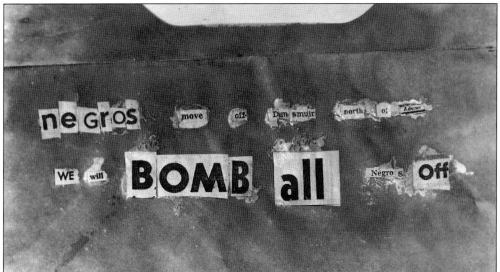

Middle school science teacher William Bailey's home was bombed on March 16, 1952, around 4:00 a.m. This photograph was taken the next day. Bailey, his wife, and 12-year-old son escaped without serious physical harm; however, the window of the front room was blown out and the furniture demolished. The Bailey's home, located at 2130 South Dunsmuir Avenue, was on the Westside, an area that had recently been opened to African American renters and purchasers. Pictured here, the note found after the bombing reads, "negros move off Dunsmuir north of Adams we will BOMB all Negros off." (Courtesy of Herald-Examiner Collection/Los Angeles Public Library.)

The Laws family awaits the verdict in their housing discrimination trial. They fought and won a lengthy legal battle to remain in the home they owned at 1235 East Ninety-second Street. In 1942, the family was told that African Americans were barred from the neighborhood and ordered to move. Pauletta Laws and her parents were jailed for disobeying a court order to vacate. After the U.S. Supreme Court ruled on May 3, 1948, that racially restrictive covenants were unenforceable, the Laws family was allowed to stay. The family, from left to right, includes son-in-law Anton Fears, his wife Pauletta Fears, and her parents, Anna and Harry Laws. (Courtesy of the Southern California Library.)

Attorney and journalist Loren Miller wrote for the *California Eagle* and the *Los Angeles Sentinel*. As a successful advocate for African Americans, Miller won cases that struck down discrimination based on race. He partnered with Thurgood Marshall on *Shelley v. Kraemer* (1948), in which the Supreme Court declared that racial covenants on property cannot be enforced by the courts. In 1951, Charlotta Bass sold the *California Eagle* to Miller, but to accept a judgeship, he sold the paper to investors in 1964. Later that year, the paper folded. (Courtesy of the Institute for Arts and Media, Harry Adams Collection, CSUN.)

On February 10, 1965, supervisor Kenneth Hahn (seated) signs a proclamation designating February 7–14 as Negro History Week in Los Angeles County. Others present at the ceremony are, from left to right, Vassie D. Wright, Madelene V. Dane, and Frank Allen, cochairperson of Negro History Week. (Courtesy of Herald-Examiner Collection/ Los Angeles Public Library.)

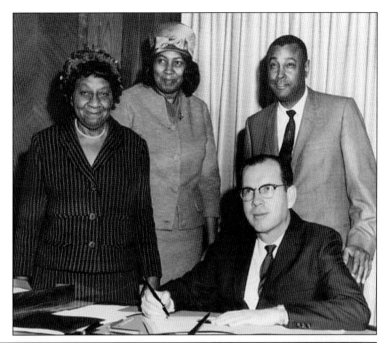

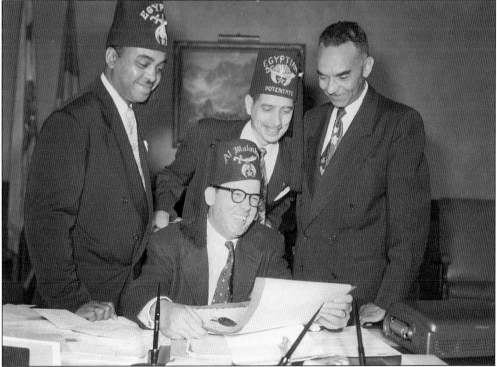

Unidentified Shriners are shown here with Los Angeles mayor Norris Paulson (seated), who served at the height of the civil rights movement from 1953 to 1961. Paulson was instrumental in the integration of the city's fire and police departments. He also encouraged freeway development and helped lure the Dodgers from Brooklyn. (Courtesy of the Institute for Arts and Media, Charles Williams Collection, CSUN.)

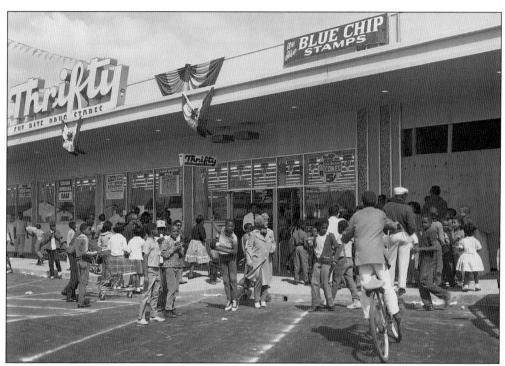

Thrifty Drug Stores were known for ice cream cones. Perhaps more popular were the Blue Chip Stamps, which could be traded for household goods and other items. This image is dated March 15, 1962. (Courtesy of the Institute for Arts and Media, Harry Adams Collection, CSUN.)

Two African American women make donuts from scratch in a bakery in 1957. African American women traditionally have been well known for their culinary skills, and this bakery is another illustration of a thriving small business in South Central. (Courtesy of the Institute for Arts and Media, Harry Adams Collection, CSUN.)

Four

CONFRONTING RACE

Dr. Martin Luther King Jr. speaks at Second Baptist Church in 1964. At age 35 that year, Dr. King was the youngest man to receive the Nobel Peace Prize. The Baptist minister and civil rights leader became an icon for justice at the age of 26 in 1955, when he led the Montgomery, Alabama, bus boycott, and in 1957, he became the founding president of the Southern Christian Leadership Conference (SCLC). Before his assassination in Memphis in 1968, Dr. King had traveled to Los Angeles on several occasions to meet and organize with activists against racial discrimination. (Courtesy of the Institute for Arts and Media, Harry Adams Collection, CSUN.)

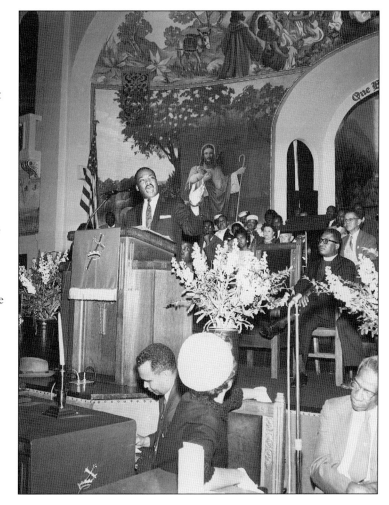

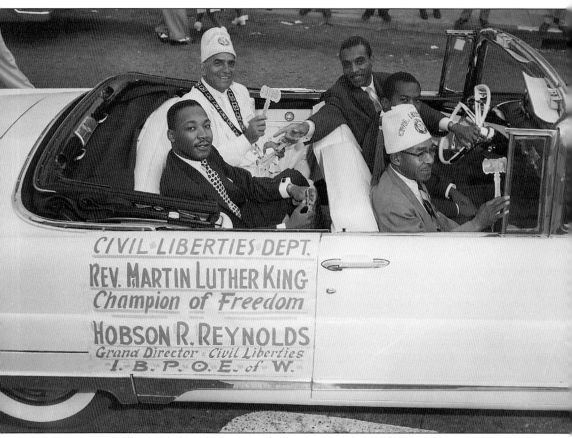

Dr. Martin Luther King Jr. visits Los Angeles to receive an award from the Improved Benevolent Protective Order of Elks of the World. The Lovejoy Award was given to those citizens who "made a great contribution towards the advancement of minority groups in America." Dr. King rides with members of the Elks. (Courtesy of the Institute for Arts and Media, Harry Adams Collection, CSUN.)

The NAACP's "Don't Buy Where You Can't Work" campaign was organized by journalist Leon Washington. In July 1957, several protesters hold signs that asked, "Did a Negro Clerk Make the Sale??" to highlight the lack of African American employees in businesses that were patronized by African Americans. Leon Washington founded the African American newspaper *Los Angeles Sentinel* in 1933. (Courtesy of the Institute for Arts and Media, Harry Adams Collection, CSUN.)

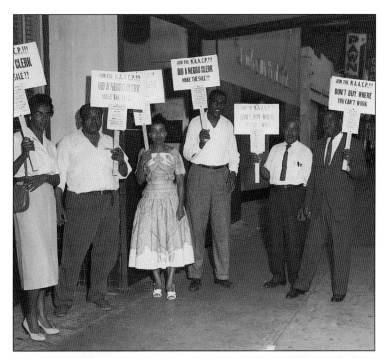

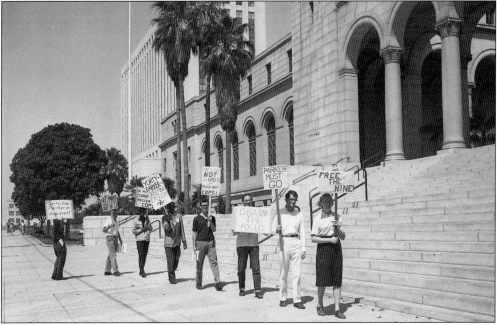

This protest in August 1962 reflects the difficult relationship between the LAPD and the African American community. William H. Parker served on the force for 39 years, starting on August 8, 1927, and became chief on August 9, 1950. Although Parker has been lauded for creating a more professionalized force, the LAPD earned a reputation for brutality and racial animosity. In addition to economic and educational inequality, the issue of police misconduct in the African American community eventually led to the Watts Riots of 1965. Chief Parker served until his death in 1966. (Courtesy of the Institute for Arts and Media, Harry Adams Collection, CSUN.)

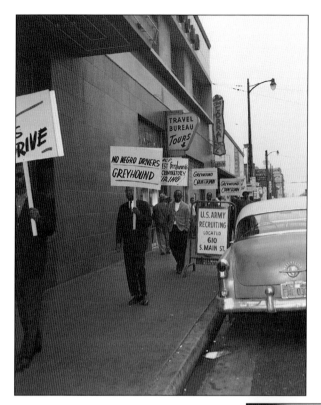

African American activism to gain opportunities for good jobs and decent wages was ongoing. The pickets against Greyhound in October 1961 were indicative of unequal status in job opportunities, promotions, and training in transportation as well as in other industries. Here blacks demanded that Greyhound hire drivers from their community. (Courtesy of the Institute for Arts and Media, Harry Adams Collection, CSUN.)

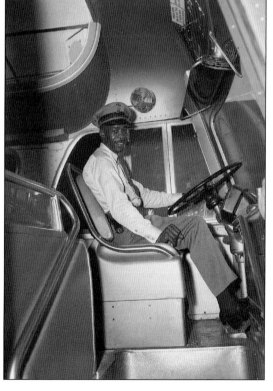

Activism targeting equal employment opportunities began to pay off. African Americans were hired to work as drivers on metropolitan and Greyhound buses, which crossed city and state lines. (Courtesy of the Institute for Arts and Media, Harry Adams Collection, CSUN.)

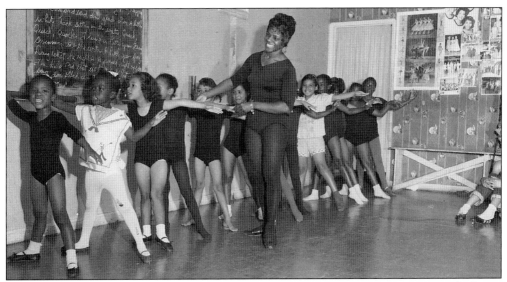

A smiling teacher with happy children at a dance studio illustrates important aspects of African American life—improvisation and performance. In this June 1961 photograph, the teacher emphasizes performance dance. (Courtesy of the Institute for Arts and Media, Harry Adams Collection, CSUN.)

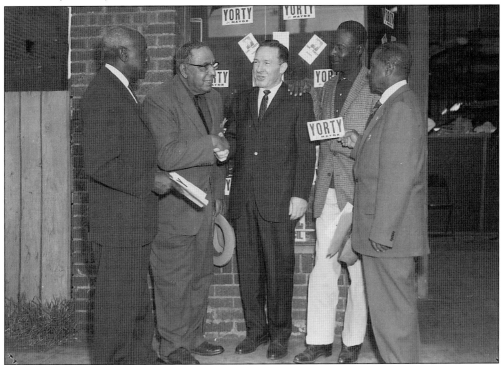

Several African Americans meet with Mayor Samuel W. Yorty in front of his campaign headquarters on March 18, 1961. Yorty served as mayor of Los Angeles from 1961 to 1973. Disaffection with high unemployment and law enforcement under his watch contributed to the Watts Rebellion of August 1965—and eventually the election of Tom Bradley, an African American, as Yorty's successor. (Courtesy of the Institute for Arts and Media, Harry Adams Collection, CSUN.)

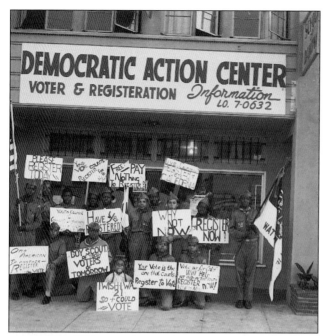

African American children in the South and West were involved in advocating for racial change through electoral politics. Here the Democratic Action Center and Boy Scotts join to promote voter registration. What is interesting in this photograph is that the office is located in Watts, signified by the phone number prefix LO, which stood for Logan. During this time period, phone number prefixes identified locations. (Courtesy of the Institute for Arts and Media, Harry Adams Collection, CSUN.)

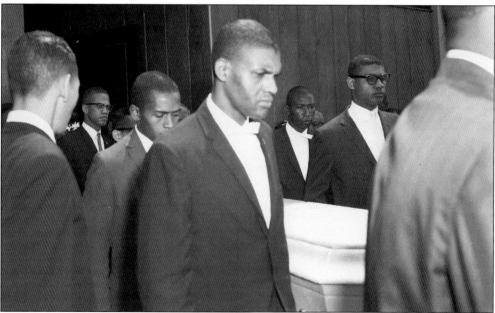

On the night of April 27, 1962, several unarmed Muslims of the Nation of Islam in Los Angeles were shot by police. The incident occurred after officers accused Ronald Stokes of selling clothes without a license. Stokes, who had come from the cleaners, challenged the assertions. After an argument ensued, Stokes was shot in the head. Upon hearing the gunshots, several Muslims in a mosque at Fifty-seventh Street and Broadway rushed outside and were also met with bullets. Stokes was killed, William Rogers was paralyzed, and the remaining members involved were wounded. Here, in May 1962, pallbearers carry Stokes's casket as minister Malcolm X, spokesperson for the Nation of Islam, walks through the doorway. (Courtesy of the Institute for Arts and Media, Harry Adams Collection, CSUN.)

Malcolm X (left) is pictured on May 16, 1962, seeking justice for Ronald Stokes and the other Muslims harmed during the shooting. During his visit, Malcolm X held a press conference, attended several meetings, and conducted the funeral for the slain Muslim. Loren Miller and Earl Brody Sr. became the defense attorneys in the case. Meanwhile the Los Angeles coroner's jury inquiry into Stokes's death ruled the shootings justifiable and in self-defense. Below, Malcolm X (center of photograph) is shown in the courtroom on the same day. (Both, courtesy of the Institute for Arts and Media, Harry Adams Collection, CSUN.)

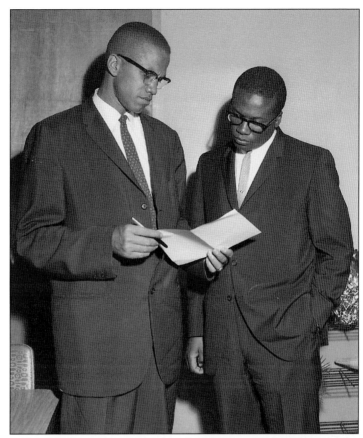

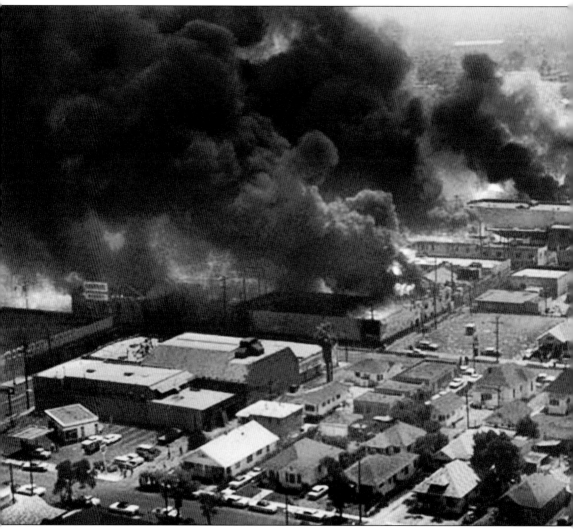

In 1965, the Watts community of Los Angeles erupted in violence and flames as African Americans expressed long pent-up rage against the LAPD and the economic, political, and social disparity between blacks and whites. The event was sparked after a California highway patrolman pulled over Marquette Frye, whom he accused of driving erratically. Events escalated after the two argued over the stop. The uprising lasted six days. At its end, 34 people were dead, 1,032 injured, and 3,952 arrested. More than $40 million in damages resulted, and over 1,000 buildings were damaged or destroyed. This aerial view shows several Watts buildings on fire. (Courtesy of Herald-Examiner Collection/Los Angeles Public Library.)

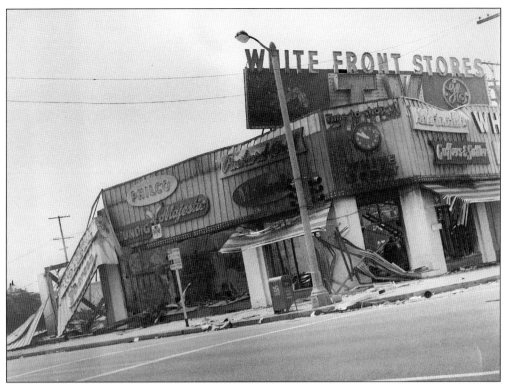

A White Front Store is shown here, damaged as a result of the 1965 Watts Riots. (Courtesy of the Institute for Arts and Media, Guy Crowder Collection, CSUN.)

Police engage in a shakedown of African Americans after stopping cars at Florence Avenue and Hoover Street. The suspects were taken to the police station after men's clothing of various sizes was found in the trunk of their car. This photograph is dated August 10, 1965, the day *before* the Watts Riots broke out. (Courtesy of Herald-Examiner Collection/ Los Angeles Public Library.)

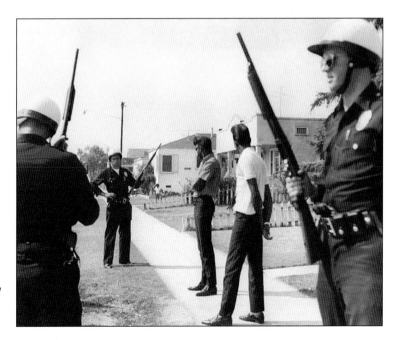

The Watts Prophets combined jazz, spoken word, and poetry to entertain and educate audiences about urban problems. Formed in 1967, the group's members were Richard A. DeDeaux, Otis O'Solomon, and Anthony (Amde) Hamilton. They released two albums, *The Black Voices: On the Streets in Watts* (1969) and *Rappin' Black in a White World* (1971). (Courtesy of SPNB: L.A. Neighborhoods Project/Los Angeles Public Library.)

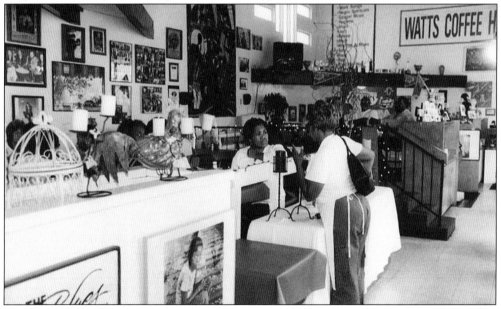

The Watts Coffee House was a community center opened after the uprising in Watts. Located in the Mafundi Community Center at 103rd Street and Wilmington Avenue, its walls were adorned with photographs and memorabilia of African Americans. Here owner Desireo Edwards chat with regular customers. (Courtesy of SPNB: L.A. Neighborhoods Project/Los Angeles Public Library.)

The annual Watts Summer Festival began after the uprising and was designed to instill pride in the African American community. During the second festival, Zawadie Zumditie (foreground), displays art objects. Albert Stone (center), a singer, holds some of his records. Patricia Woodlin (rear), models some of the fashions created by Zumditie, a professional designer. This photograph was taken August 5, 1967, outside the Watts Summer Festival office at 10301 South Central Avenue, in Watts. (Courtesy of Herald-Examiner Collection/Los Angeles Public Library.)

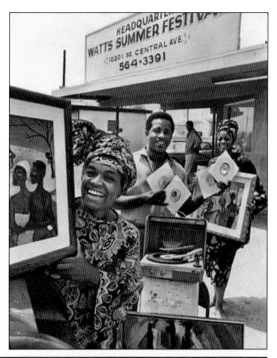

Joe Louis (standing), seen here between 1959 and 1961, was the world heavyweight champion prizefighter from 1937 to 1948. He defended his title 20 times in four years. His rematch with German fighter Max Schmeling in 1938 was one of the most famous boxing matches of all time—considering that the earlier defeat of Louis was claimed by Nazis as proof of their doctrine of Aryan superiority. The rematch, won by Louis, lasted two minutes and four seconds. After marrying Los Angeles attorney Martha Malone Jefferson, Louis moved to Los Angeles. (Courtesy of the Institute for Arts and Media, Harry Adams Collection, CSUN.)

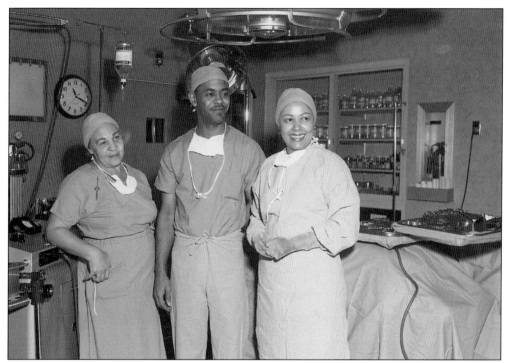

A surgeon and staff at Avalon Memorial Hospital are shown in March 1962. The hospital was located at 5862 South Avalon Boulevard and served a predominantly minority community. In the 1960s, the National Medical Association (NMA) fought to desegregate medical and nursing schools, endorsed the civil rights movement, and worked to remove racial restrictions from admissions to the American College of Surgeons board. (Courtesy of the Institute for Arts and Media, Harry Adams Collection, CSUN.)

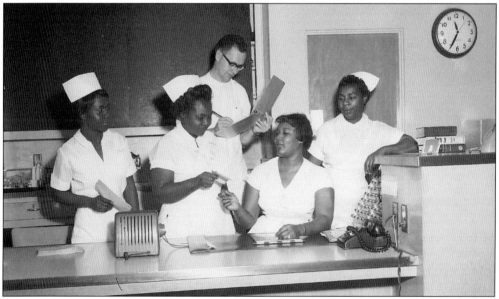

Several nurses are pictured at Avalon Memorial Hospital on March 15, 1962. (Courtesy of the Institute for Arts and Media, Harry Adams Collection, CSUN.)

Minister and state legislator Douglas Ferrell (center) shakes hands with boxing champion Muhammad Ali (right). In 1944, Ferrell was a founder of the Tabernacle of Faith's Baptist Church, located at 1767 East 103rd Street. Pastor Ferrell was noted for his efforts in broadening the duties of the church. In 1954, he organized the Tabernacle of Faith Federal Credit Union, and in 1956, he built a church on the island of Jamaica. In 1962, Ferrell was elected to the California State Assembly from the 55th District. He served for two terms, voluntarily retiring in December 1966. (Courtesy of the Institute for Arts and Media, Harry Adams Collection, CSUN.)

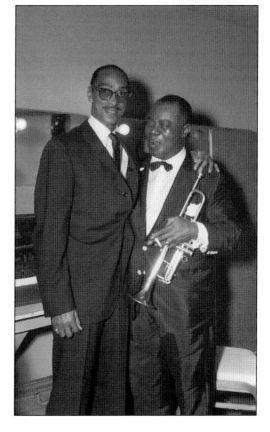

Louis "Satchmo" Armstrong (right) moved to Los Angeles in July 1930. He fronted Les Hite's Orchestra, which he later renamed Louis Armstrong's Sebastian New Cotton Club Orchestra, after a club on Washington Boulevard in Culver City, California, where the band played. Armstrong is pictured here with an unidentified fan in his dressing room in October 1961. (Courtesy of the Institute for Arts and Media, Harry Adams Collection, CSUN.)

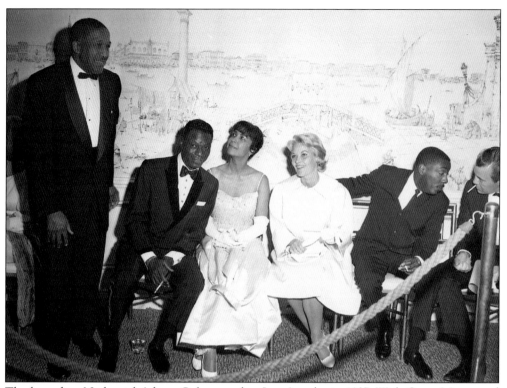

The legendary Nathaniel Adams Cole moved to Los Angeles in 1937. With Oscar Moore and Wesley Prince, Nat King Cole made up one third of the King Cole Trio. One of their pop hits included "Straighten Up and Fly Right." Cole's later solo career included the hits "Unforgettable," "The Christmas Song," and "(I Love You) For Sentimental Reasons." He was one of the few African Americans to host a television variety show and was the first black person to live in the Hancock Park district of Los Angeles, experiencing racial animosity from some neighbors. Pictured on August 5, 1962, from left to right, are Dr. Leroy Weeks, Cole, Maria (his wife), unidentified, comedian Dick Gregory, and unidentified. (Courtesy of the Institute for Arts and Media, Harry Adams Collection, CSUN.)

Horace Tapscott, the legendary jazz musician, founded the Pan Afrikan Peoples Arkestra, an avant-garde group of artists whose musical performances involved singing, dancing, and poetry. Originally from Houston, Texas, Tapscott moved with his family to Los Angeles at age nine, around 1943. He attended Jefferson High School and served in the air force. Throughout his career, Tapscott played with many jazz greats, including John Coltrane and Eric Dolphy. He was also an outspoken critic of racism and injustice. (Courtesy of Michael Dett Wilcots.)

John Outterbridge, an African American assemblage artist, also well known for his unique sculpture, was the first director of the Watts Tower Art Center. His art has been featured in various museums throughout the United States. Originally from North Carolina, he currently resides in Los Angeles. (Courtesy of the Institute for Arts and Media, James Jeffrey, CSUN.)

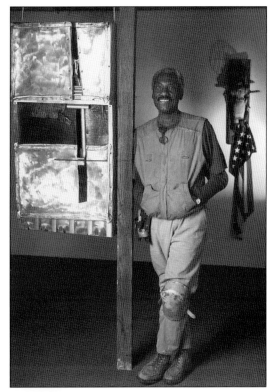

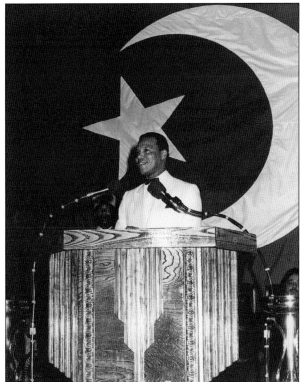

After the death of Nation of Islam leader Elijah Muhammad, minister Louis Farrakhan became a leader in the fragmented organization in 1978. He was a protégé of Malcolm X and a former head minister of temples in Boston and Harlem. Farrakhan's visits to Los Angeles were frequent. Here Farrakhan is shown at the podium of the Los Angeles Mosque in the 1970s. (Courtesy of the Institute for Arts and Media, Guy Crowder Collection, CSUN.)

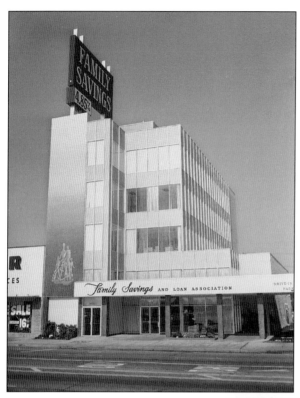

Family Savings and Loan, now One United Bank, was a major institution in black Los Angeles, allowing money earned by its members to help develop the community. (Courtesy of the Institute for Arts and Media, Harry Adams Collection, CSUN.)

In 1950, Dr. Ralph Bunche became the first African American to receive the Nobel Peace Prize. Bunche, his two sisters, and grandmother moved to Los Angeles after the death of his parents. Bunche was valedictorian of his class at Jefferson High School and won an athletic scholarship to UCLA. Bunche received a doctoral degree in political science from Harvard University, taught at Harvard, and chaired the Department of Political Science at Howard University. From 1955 to 1967, he served as undersecretary for Special Political Affairs, undersecretary-general of the United Nations, and special representative overseeing the U.N. commitments in the Congo. The City of Los Angeles declared Dr. Ralph Bunche Day in 1949, after his successful mediation of negotiations between Israel and the Arab states, for which he won the Nobel Peace Prize. (Courtesy of the Institute for Arts and Media, Harry Adams Collection, CSUN.)

Jackie Robinson (left) was the player who broke the color barrier in Major League Baseball (MLB) in 1947. After his family moved to Los Angeles from Georgia, Robinson attended John Muir High School, Pasadena Junior College, and UCLA. He played in the Negro Leagues until he was selected by Branch Rickey, a vice president with the Brooklyn Dodgers, to help integrate the MLB. Robinson played with the Dodgers from 1947 to 1956. The team moved to Los Angeles in 1958. Throughout the years, the Los Angeles Dodgers have celebrated Jackie Robinson's contribution to their team and to baseball. Robinson and Brad Pye, a writer for the *Los Angeles Sentinel* and the former *California Eagle*, shake hands on March 15, 1962, during one of Robinson's visits to Los Angeles. (Courtesy of the Institute for Arts and Media, Harry Adams Collection, CSUN.)

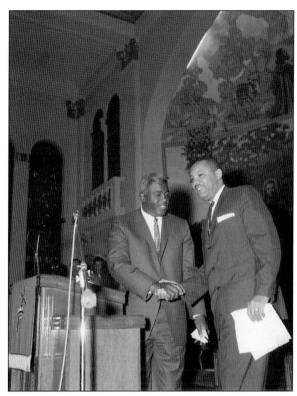

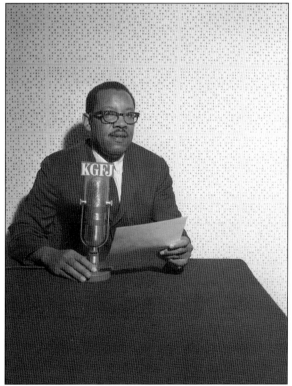

In 1959, KGFJ became one of the first radio stations in the United States to target the black community as its primary audience. Here journalist Brad Pye speaks into a microphone at the station in 1968. KGFJ was the only radio or television station allowed by the black community to cover the Watts Rebellion in 1965. (Courtesy of the Institute for Arts and Media, Harry Adams Collection, CSUN.)

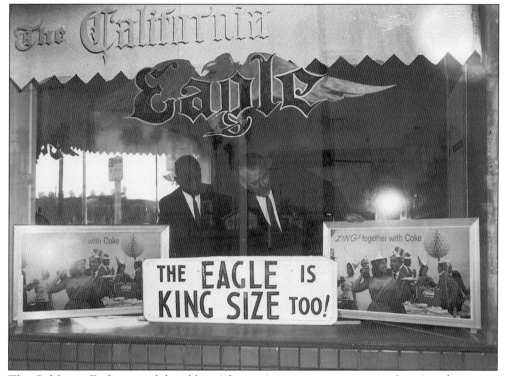

The *California Eagle*, one of the oldest African American newspapers in Los Angeles, traces its origins to 1879. John J. Neimore, the founder and editor, had escaped slavery in Missouri. Originally called the *Owl*, the paper was renamed the *Eagle* in 1912 and lasted until 1964. It served as a source of information and inspiration for the black community, which had been ignored or negatively portrayed by the predominantly white press. This photograph was taken in January 1964. (Courtesy of the Institute for Arts and Media, Harry Adams Collection, CSUN.)

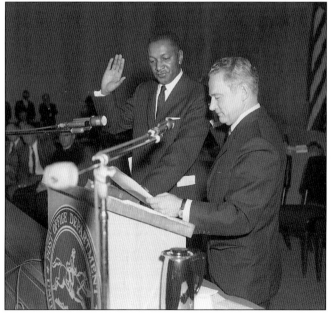

Leslie N. Shaw was sworn in as the first African American postmaster of a major American city (Los Angeles) in April 1963. His postal area was the third largest in the country, covering 240 square miles, with 54 carrier stations and 10,200 employees. Shaw, an entrepreneur, was also acting president of the Family Savings and Loan Association. (Courtesy of the Institute for Arts and Media, Harry Adams Collection, CSUN.)

This January 1968 image shows three African Americans of the Los Angeles city attorney's office. Johnnie L. Cochran Jr. (center) later established a successful law practice and is famous for defending O. J. Simpson and Black Panther leader Elmer Geronimo Pratt. Consuelo Bland Marshall (right) became a federal judge for the Central District of California. Nelson L. Atkins (left) entered private practice with Cochran. He is currently an arbitrator for the superior court in Los Angeles County and the American Arbitration Association. (Courtesy of the Institute for Arts and Media, Harry Adams Collection, CSUN.)

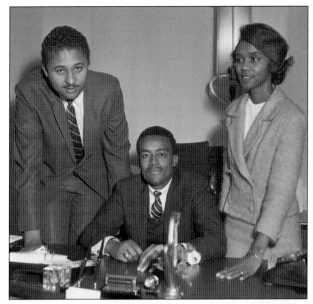

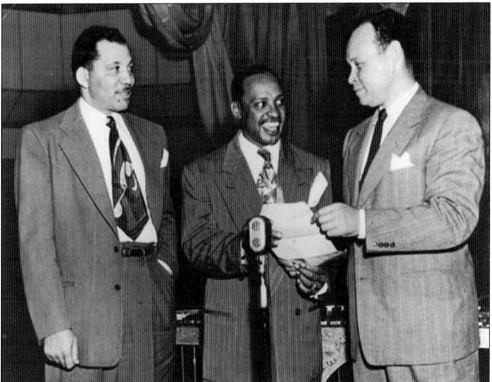

A presentation is made by bandleader Lionel Hampton (center) to Dr. Charles Drew (right) and attorney Walter Gordon (left) at the old Sebastian's Cotton Club. Drew was a great sprinter and athlete who founded the Blood Plasma Bank. Charles Drew University of Medicine and Science, located in the Watts-Willowbrook section of South Los Angeles, is named for him. The university was incorporated in August 1966 as a nonprofit educational institution in response to the lack of adequate medical facilities in the area.

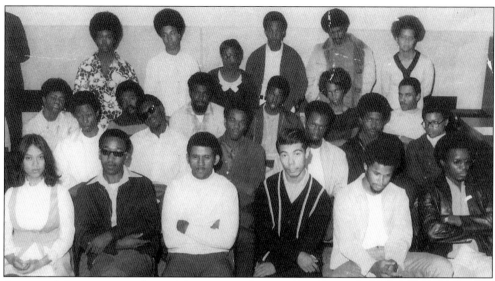

As part of the movement for social justice, students at San Fernando Valley State College in Northridge took over the administration building in 1968 in order to force negotiations with administrators. An important outcome was the Pan-African Studies Department, chartered in 1969. The San Fernando Valley State College students pictured above were arrested on charges including kidnapping, robbery, and conspiracy for their involvement, even though they were unarmed. Lawyers for the student-defendants are seen below. They are, from left to right, Loren Miller Jr., Morgan M. Moten, and Halvor T. Miller Jr. (Both, courtesy of Halvor T. Miller.)

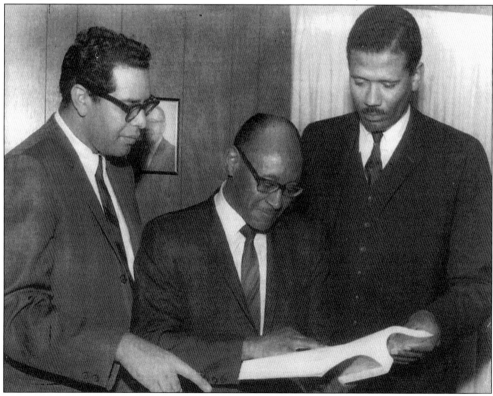

Kevin London, age six, is sitting near the family Christmas tree in 1963. The tree, with silver needles, is an example of those found in many African American homes during that time period. The London family lived on 102nd Street in Los Angeles. London attended 102nd Street School, John Muir Junior High School, and Crenshaw and Fremont High Schools. Today he works as a state engineer elevator inspector. (Courtesy of Erica Pace.)

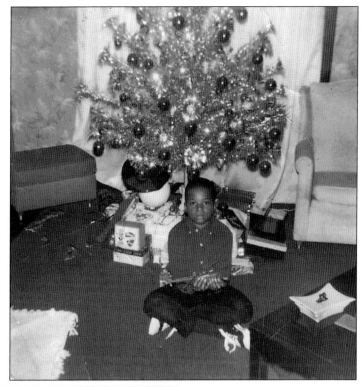

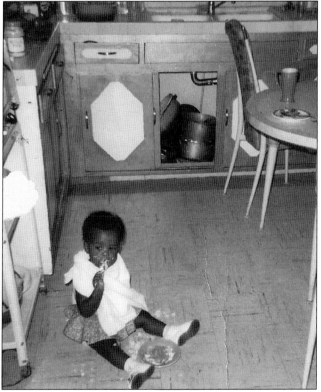

Another photograph at the London home shows Erica London, also on Christmas Day, in 1968. She is eating Christmas cake on the kitchen floor at her grandmother's house at Seventy-first Street and Vermont Avenue. London spent her early years in Los Angeles, moved to Lynwood, and finally to Culver City, where she graduated from high school. She is a college graduate, is married, and has three children. (Courtesy of Erica Pace.)

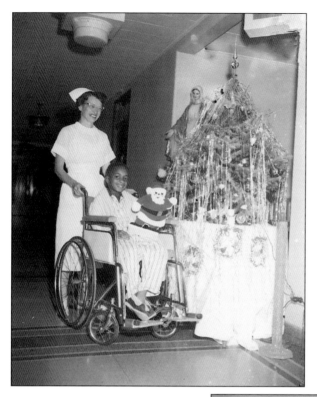

As this photograph shows, Christmas can still be a joyful time of the year, even when someone is ill. This boy is smiling while viewing a Christmas tree from his wheelchair. The photograph was taken during his stay in the hospital around 1960. (Courtesy of the Institute for Arts and Media, Harry Adams Collection, CSUN.)

This Santa Claus of African American descent represents the need for cultural identification of heroes. It also represents an emphasis on cultural heritage that engulfed the African American community during the 1960s and 1970s. (Courtesy of the Institute for Arts and Media, Harry Adams Collection, CSUN.)

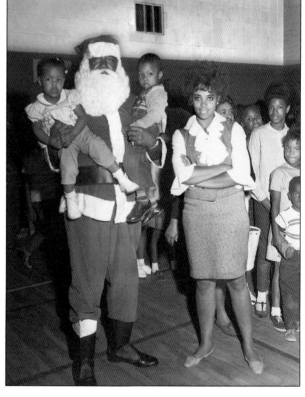

Five

MOVING BEYOND
THE CENTER

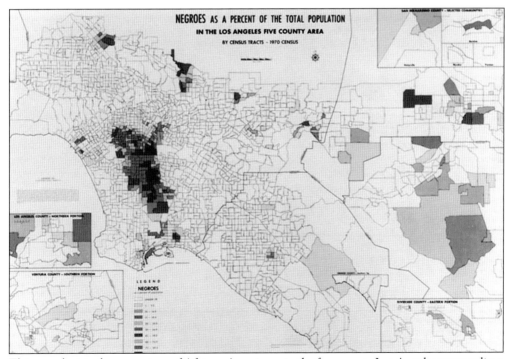

This map depicts the percentage of African Americans in the five-county Los Angeles metropolitan area by census tracts, based on the 1970 census. (Courtesy of Los Angeles Maps/Los Angeles Public Library.)

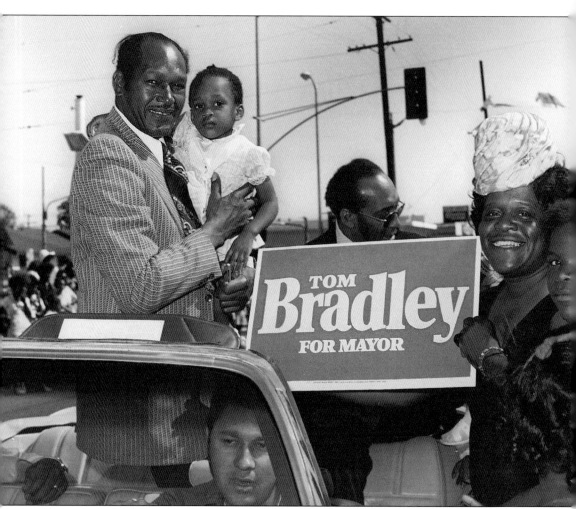

Tom Bradley is pictured here during his historical campaign for mayor of Los Angeles in 1973. As the son of a sharecropper, Bradley moved from Texas to Los Angeles with his family at age seven. In 1940, he began a 22-year tenure with the city's police department. While serving as a police officer, he earned a law degree from the Southwestern University School of Law. In 1963, Bradley became the city's first African American council member, and in 1973, he defeated Mayor Sam Yorty to become the second African American mayor of a major U.S. city (after Carl Stokes was elected mayor of Cleveland in 1967). Bradley served five terms as the city's mayor. He is most noted for transforming Los Angeles into an international business and trading center and for hosting the Olympic Summer Games in 1984. (Courtesy of the Institute for Arts and Media, Guy Crowder Collection, CSUN.)

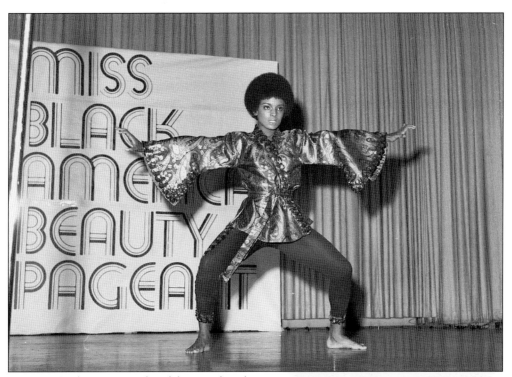

J. Morris Anderson created and first produced the Miss Black America Pageant (MBAP) on August 17, 1968. It was originally a local Philadelphia area pageant, but as a result of support from the NAACP and its protest of the Miss America pageant, the local black pageant received nationwide press coverage. NAACP leaders had long condemned the Miss America pageant for its exclusion of black women. In 1974, Von Gretchen Shepard (above and right) from Los Angeles was crowned Miss Black America. Throughout the years, Miss Black America contestants became staples in black history and culture, including Oprah Winfrey, who competed in 1971 as Miss Black Tennessee. In honor of the pageant, Curtis Mayfield wrote a song titled "Miss Black America." The Miss Black America Pageant lives on and continues to combat negative stereotypes and images of black women. (Both, courtesy of the Institute for Arts and Media, Guy Crowder Collection, CSUN.)

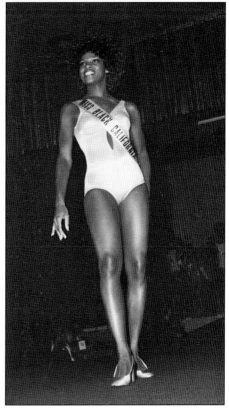

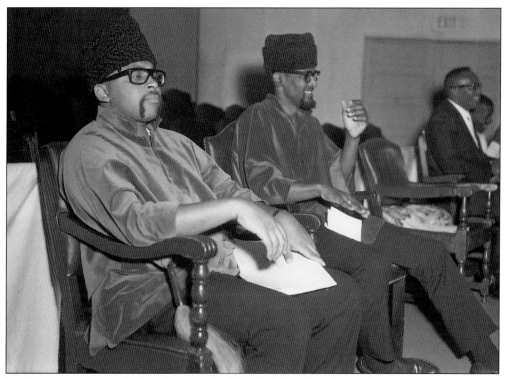

Black power activists Maulana Karenga (left) and Hakim Jamal attend a meeting. Karenga was born Ron Everett in 1941 and became a political activist, author, and professor. He is most noted as the creator of Kwanzaa, an African American celebration of family, community, and culture, which takes place from December 26 to January 1. He is also the founder of US, established on September 7, 1965, as an institution to serve the black community. Jamal knew Malcolm X in Boston, where both were street hustlers. He founded the Malcolm X Foundation in Compton and wrote about his experiences with the Muslim leader. (Courtesy of the Institute for Arts and Media, Guy Crowder Collection, CSUN.)

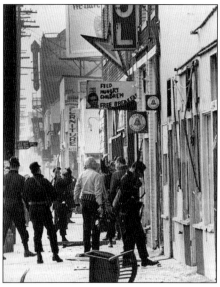

The most popular organization to come out of the Black Power movement was the Black Panther Party for Self-Defense (BPP), founded in Oakland by Huey Newton and Bobby Seale in 1966. The purpose was to politically organize and fight police brutality. A Southern California chapter was formed in 1968 by members of street gangs as well as socially conscious groups. This image was taken after a shoot-out between the LAPD and the BPP at the organization's headquarters. A "Feed Hungry Children Free Breakfast" sign advertises the BPP's free breakfast program, which fed thousands of children living in South Central. (Courtesy of the Institute for Arts and Media, Guy Crowder Collection, CSUN.)

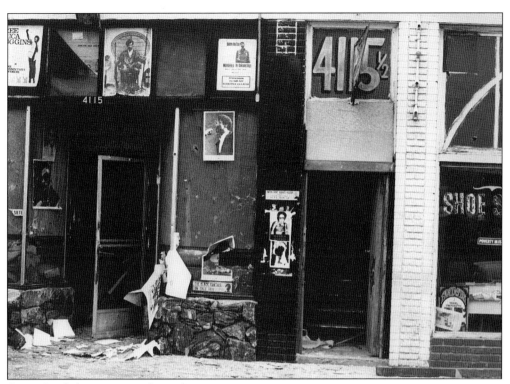

A gun battle between members of the Southern California chapter of the Black Panther Party and police occurred in April 1969 at the organization's headquarters at 4115 Central Avenue. Hundreds of LAPD officers surrounded the building, and Black Panther Party members shot back. The chapter's leader at the time, Geronimo Pratt, turned off the lights and armed the Panthers. Party members contacted the news media, ultimately prompting the LAPD to withdraw. This photograph shows the building's facade after the police began shooting. (Courtesy of the Institute for Arts and Media, Guy Crowder Collection, CSUN.)

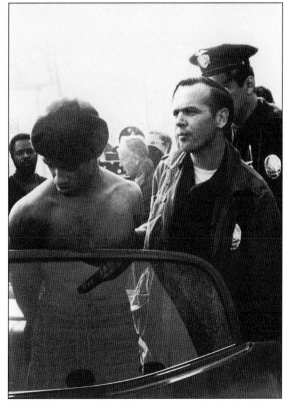

In the midst of a crowd, a member of the Black Panther Party is arrested by the LAPD. The man in police custody is wearing a black beret, one element of the BPP uniform. (Courtesy of the Institute for Arts and Media, Guy Crowder Collection, CSUN.)

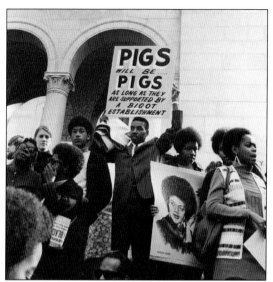

Protest over the LAPD treatment of the Black Panther Party is expressed by members of the black community. The sign reads, "Pigs will be Pigs as long as they are supported by a bigoted establishment." Another protester is holding a photograph of Kathleen Cleaver, an early member of the party who also served as its minister of communications. (Courtesy of the Institute for Arts and Media, Guy Crowder Collection, and CSUN.)

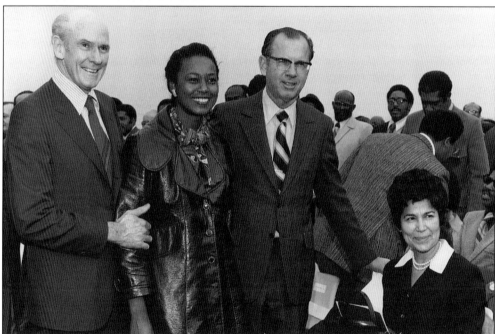

A trailblazer for African Americans and women, Yvonne Burke earned a Bachelor of Arts in political science from UCLA in 1953 and was among the first black women admitted to the University of Southern California School of Law. In 1966, she was the first black woman elected to the state assembly, and in 1972, she was the first black woman from California elected to Congress. In 1973, Burke earned distinction as the first congresswoman to give birth and be granted maternity leave while serving in the House of Representatives. California governor Jerry Brown appointed her to the Los Angeles County Board of Supervisors, the first black person to sit on that panel. In 1992, she became the first African American to win outright election as a Los Angeles County supervisor. A year later, she became the first woman and the first racial minority to chair the board. Burke has been reelected three times. (Courtesy of the Institute for Arts and Media, Guy Crowder Collection, CSUN.)

The Honorable Mervyn Dymally presents a proclamation to multi-award-winning actor and Los Angeles resident Sidney Poitier, the first African American to win an Academy Award for Best Actor, for his role in *Lilies of the Field* (1963). Dymally's political history in Los Angeles spans four decades. He initially served in the assembly from 1962 to 1966 before becoming the first African American elected to the state senate in 1966. In 1974, Dymally won his bid for the lieutenant governor's office, making him one of the nation's first black statewide elected officials. In 1980, he became a member of the U.S. Congress, representing the 31st Congressional District. (Courtesy of the Institute for Arts and Media, Harry Adams Collection, CSUN.)

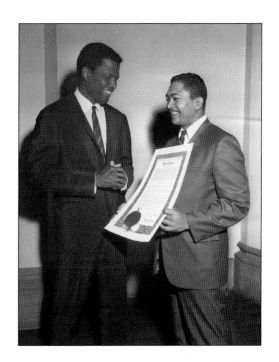

Celes King III (center), founder of the Los Angeles branch of the Congress of Racial Equality, is surrounded by supporters as he receives an award. King was born on September 18, 1923, in Chicago but moved to Los Angeles with his parents in 1938 after his family purchased the Dunbar Hotel. During World War II, he became a pilot with the famed Tuskegee Airmen. In 1951, he founded a bail bond agency with his father. (Courtesy of the Institute for Arts and Media, Guy Crowder Collection, CSUN.)

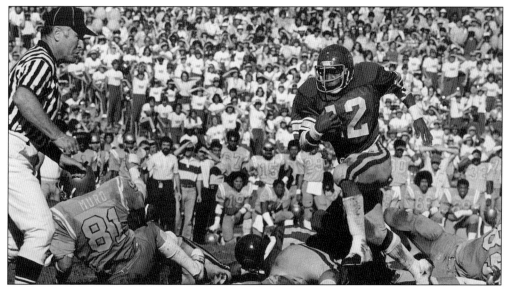

Among the great athletes in Los Angeles history have been the collegians at the University of California, Los Angeles, and Southern California University. Among the succession of great African American tailbacks at USC have been Mike Garrett, O.J. Simpson, Charles White (pictured here), and Marcus Allen – all of whom won the Heisman Trophy as college football's top player. Orenthal James "O.J." Simpson had been a champion to young people as an athlete, and turned spokesman and actor. He set several National Football League records as a member of the Buffalo Bills. "The Juice" was elected to the Pro Football Hall of Fame in 1985. Although O.J.'s football career is stunning, he will most likely be remembered as the defendant in the "trial of the century," for the murders of his ex-wife, Nicole Brown Simpson, and her friend Ronald Goldman in Brentwood in 1994. Represented by the famed lawyer Johnnie Cochran, O.J. was acquitted of the murders in 1995. (Courtesy of the Institute for Arts and Media, Guy Crowder, CSUN.)

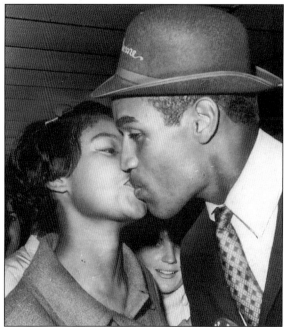

A 19-year-old O.J. Simpson married his high school sweetheart, 18-year-old Marguerite L. Whitley, on June 24, 1967. Their marriage ended after 12 years. The couple lived in Los Angeles. (Courtesy of Herald-Examiner Collection/ Los Angeles Public Library.)

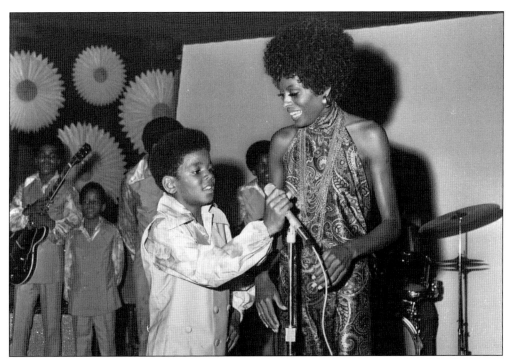

Child star Michael Jackson is pictured with his mentor, Diana Ross, the superstar of the Supremes. The two stars maintained a close bond throughout the years. His brothers, members of the Jackson 5, can be seen in the background. (Courtesy of the Institute for Arts and Media, Guy Crowder Collection, CSUN.)

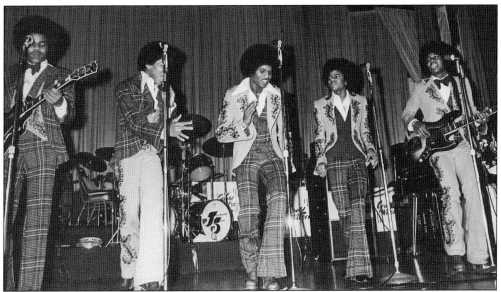

Originally from Gary, Indiana, the Jacksons moved to Los Angeles in 1970. The group's soulful singing and choreography tantalized the nation. Seeing the Jackson 5 on stage epitomizes the energy of the 1970s. The group was inducted into the Rock and Roll Hall of Fame in 1997. Inductees were, from left to right, Tito, Marlon, Jackie, Michael, and Jermaine Jackson. (Courtesy of the Institute for Arts and Media, Guy Crowder Collection, CSUN.)

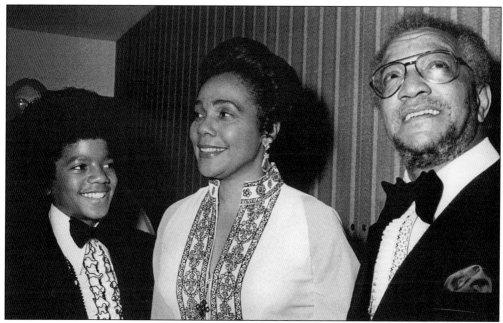

Three of the most famous African Americans in history are pictured here attending a black-tie event in Los Angeles: (from left to right) Michael Jackson, pop legend; Coretta Scott King, widow of Dr. Martin Luther King Jr., mother of four, singer, and civil rights activist; and Redd Foxx, comedian and actor. (Courtesy of the Institute for Arts and Media, Guy Crowder Collection, CSUN.)

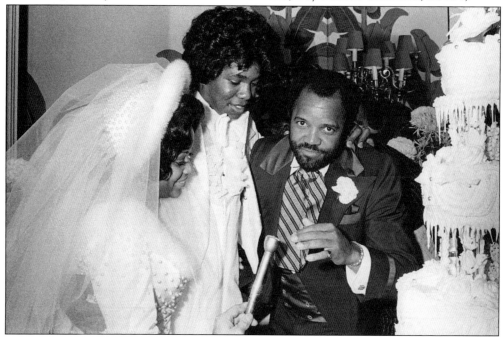

Hazel Gordy (left), daughter of Motown president Berry Gordy (right), wed Jermaine Jackson (center) of the Jackson 5 on December 15, 1973. The couple remained married for 14 years and had three children before divorcing in 1987. (Courtesy of the Institute for Arts and Media, Guy Crowder Collection, CSUN.)

During the 1970s, facial hair on men was a fashion statement. Men clipped and shaped mustaches and beards to their liking—the thicker the mustache, the better. Alfred (right) and Herbert Hunt here enjoy an evening with family. (Courtesy of Alna and Mel Brown.)

In 1971, Toni Monique Grayson graduated from the Head Start Program at age four. Project Head Start was announced by Pres. Lyndon B. Johnson in May 1965 as part of his War on Poverty. The essence of the program is the belief that education eradicates poverty. Head Start provides preschool children from low-income families with a comprehensive program to meet emotional, social, health, nutritional, and psychological needs. The Head Start Program attended by Grayson was located on Figueroa and Ninety-first Streets. (Courtesy of Robert Grayson.)

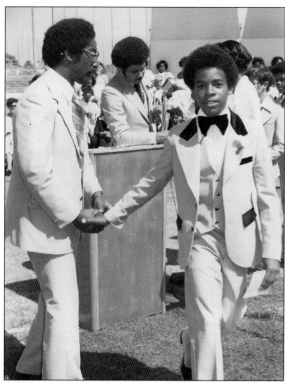

Mel Brown Jr. (right) is seen here graduating from high school in 1978. Shaking the graduate's hand after Brown received his diploma is Edward Vincent, the first African American mayor of the City of Inglewood. Vincent served in the California State Assembly and is a current member of the California State Senate, representing Senate District 25. (Courtesy of Alna and Mel Brown.)

African American Girl Scouts pose in uniform at a meeting in 1987. The Girl Scouts of America, founded in 1912, has long been considered the premier organization dedicated to building character and leadership skills for girls. Activities range from community service to traveling and raising awareness of important issues affecting women and girls. (Courtesy of the Institute for Arts and Media, Guy Crowder Collection, CSUN.)

Dr. Anyim C. Palmer (right) founded Marcus Garvey School with his life's savings—$20,000. Originally from Texas, Palmer migrated to Los Angeles as a young adult and received an Associate of Arts (AA) degree in 1960 from Los Angeles City College and his doctorate in secondary educational administration and political science in 1972 from Claremont Graduate School. In 1975, Palmer established the Garvey School using an Afrocentric model of educating African American children. The school has received national acclaim for its academic achievements. An unidentified student (below) tackles English at Marcus Garvey Elementary School on December 20, 1981. (Right, courtesy of Marcus Garvey School; below, courtesy of Herald-Examiner Collection/ Los Angeles Public Library.)

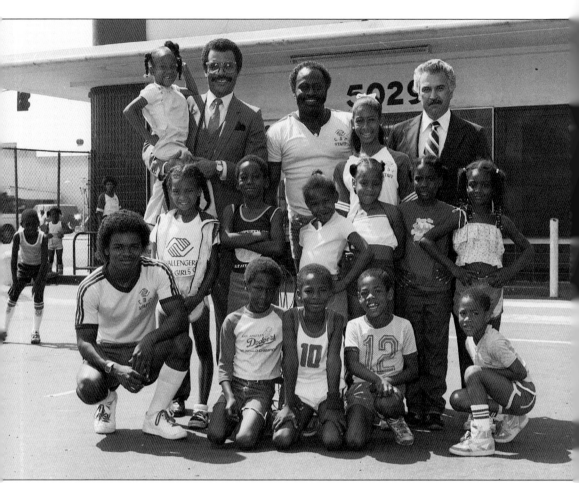

The motto of the Challengers Boys and Girls Club is "a positive place for kids." The organization was founded in 1968 after Lou Dantzler, a South Central Los Angeles father, caught a boy attempting to break into his home. Instead of punishing the child, Dantzler decided to work with him and others to change their lives. The Challengers Boys and Girls Club has now served thousands of children in South Los Angeles by providing them with education, leadership skills, physical fitness, and a host of other life-enhancing skills. (Courtesy of the Institute for the Arts and Media, Guy Crowder Collection, CSUN.)

Six

TO EMPOWER
THE COMMUNITY

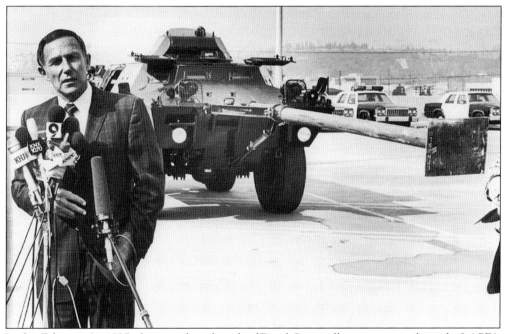

In this February 21, 1985, photograph, police chief Daryl Gates talks to reporters about the LAPD's new tank-like personnel carrier, with a steel battering ram (seen in the background), to be used against "rock houses." Eventually police officers switched to the actual ram arm, now hand-held, without the entire vehicle, which was too large to get into smaller areas. Today the kind of house targeted by the LAPD is known as a crack house. (Courtesy of Herald-Examiner Collection/Los Angeles Public Library.)

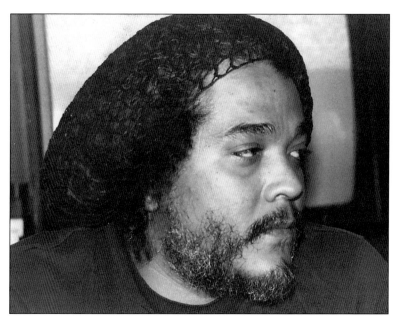

Michael Zinzun was a member of the Black Panther Party and a community activist. He was well known for fighting for social justice and against police brutality in Los Angeles. He won an important lawsuit against the LAPD for police abuse. Born in 1949, Zinzun died in 2006. (Courtesy of James Simmons.)

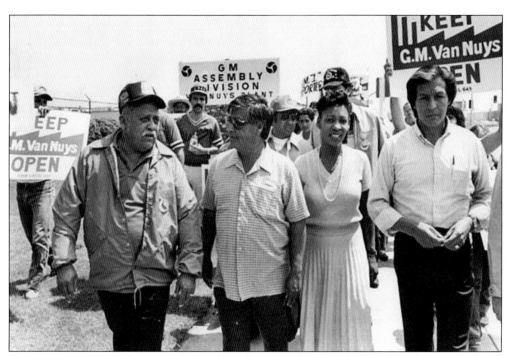

One important goal of this march was to keep General Motors in the Los Angeles neighborhood of Van Nuys to maintain employment for its residents. Famed labor leader Cesar Chavez led this protest. Depicted are some former employees of GM, along with congresswoman Maxine Waters, marching and protesting with signs and banners. (Courtesy of the Institute for Arts and Media, Guy Crowder Collection, CSUN.)

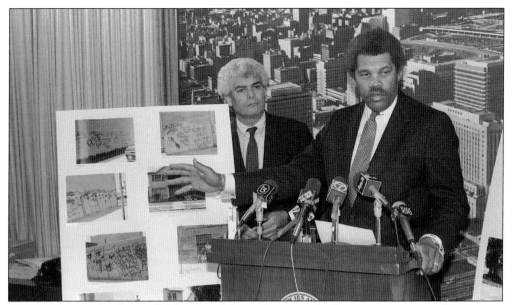

District Attorney Ira Reiner (left) and an African American leader present a program for cleaning up graffiti in South Los Angeles. Although many youth use graffiti as a way of self-expression, to others it is both a debasement of property and a crime. Graffiti received widespread attention during the 1970s and 1980s as a result of its connection to hip-hop music. Examples of graffiti are shown on the poster. (Courtesy of the Institute for Arts and Media, Guy Crowder Collection, CSUN.)

Police officers and community activists walk through the Imperial Courts projects. Drugs and violence have engulfed these kinds of housing developments, where residents suffer from inadequate income and poor infrastructure. (Courtesy of Herald-Examiner Collection/Los Angeles Public Library.)

Crenshaw Christian Center was founded by Dr. Frederick K. C. Price in 1973 with approximately 300 members and grew to 18,000 members by 2010. Located on Vermont Avenue, the Faith Dome is a geodesic dome—one of the largest in the world. It is used for Sunday services, special meetings, conventions, and crusades. Established in 1985, the Crenshaw Christian Center Ministry Training Institute, which includes a correspondence school program that was founded in 1994, is also located on the grounds. The church is noted for volunteerism, outreach jail ministry, and work with other inner-city ministries. (Courtesy of the Institute for Arts and Media, Guy Crowder Collection, CSUN.)

Founded by C. E. Church Sr. in 1943, the West Angeles Church of God in Christ was first located on Vermont Avenue in the heart of South Los Angeles. Through the years, the church has grown to exceed 22,000 members. It is considered a megachurch (defined as having more than 2,000 weekly attendees), with extensive ministry and outreach services including television and radio broadcasts. Pastor Bishop Charles E. Blake also serves as presiding bishop of the 6 million–member Church of God in Christ located on Crenshaw Boulevard. (Courtesy of Logan Hartley.)

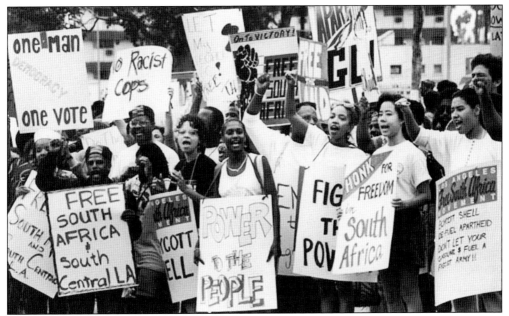

Depicted here is a Free South Africa Movement march and rally that took place during the 1980s. The march marked the U.N. Day of Solidarity with South African political prisoners. The group assembled at Jackie Robinson Stadium and marched throughout South Central. The demonstrators called for boycotts of companies that did business with the apartheid government of South Africa. (Courtesy of Los Angeles Public Library.)

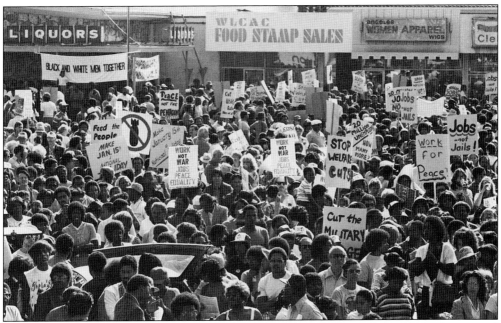

By this time African Americans in Los Angeles had become well known for their informational campaigns and protest activities. This demonstration took place during the 1980s. Highlighted is the movement to make Martin Luther King Jr. Day a federal holiday, along with antiwar and poverty sentiments. (Courtesy of the Institute for Arts and Media, Guy Crowder Collection, CSUN.)

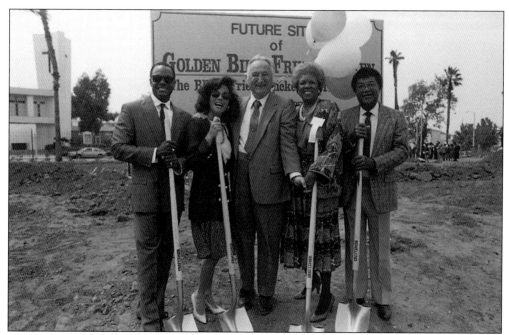

The first Golden Bird opened in Los Angeles in 1953. This groundbreaking ceremony was held at Marlton Avenue and Santa Rosalia Drive on April 14, 1989. Golden Bird is noted for its good food and community sponsorships. (Courtesy of the Institute for Arts and Media, Harry Adams Collection, CSUN.)

Papa's was one of the few grocery stores in Los Angeles owned and operated by African Americans. The store was located at 4375 South Van Ness Boulevard. On the day this photograph was taken, May 25, 1988, Papa's Groceries cosponsored a supermarket shopping spree with radio station KACE and BRE to benefit the Genesee Center for Battered Women. (Institute for Arts and Media, Guy Crowder Collection, CSUN.)

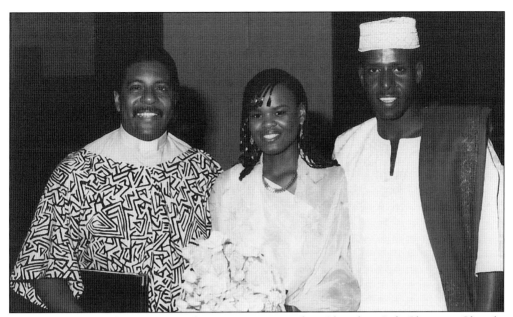

Vanessa Vinson and Hassan Mogeh Hirsi were married at Abundant Life Christian Church, located at 3500 Normandie Avenue. Rev. John E. Tunstall IV performed the March 28, 1988, ceremony. (Courtesy of Vanessa and Hassan Hirsi.)

Omar Mohamed and Stephanie Jones were groomsman and bridesmaid in the Hirsi wedding. Mohamed and Hirsi are longtime friends of the same Somali heritage. Jones met Vinson in college. The two look regal as they walk down the aisle in traditional African attire. (Courtesy of Vanessa and Hassan Hirsi.)

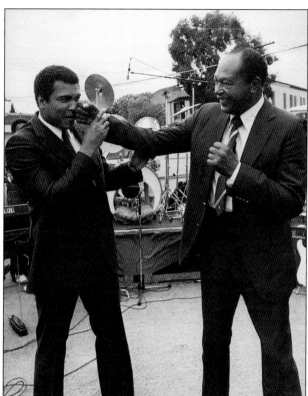

Tom Bradley (right) and Muhammad Ali (left) share a light moment. Ali, three-time World Heavyweight Champion, is considered by many to be the greatest heavyweight boxer ever. Although Ali did not reside in Los Angeles, he was a frequent visitor. (Courtesy of the Institute for Arts and Media, Guy Crowder Collection, CSUN.)

Mayor Tom Bradley (center) stands with dignitaries at a reception for the 1984 Summer Olympic Games in Los Angeles, which were seen as a financial success. Bradley strictly controlled expenses by using existing facilities and attracting corporate sponsors. (Courtesy of the Institute for Arts and Media, Guy Crowder Collection, CSUN.)

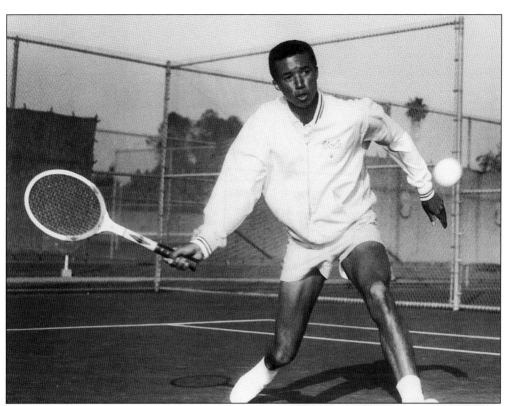

The NCAA men's singles tennis champion in 1965, Arthur Ashe led UCLA to a team title as well. He became the first African American man to win the U.S. Open and Wimbledon. Off the court, he raised awareness about apartheid in South Africa, wrote an influential history of African American athletes titled *A Hard Road to Glory*, and, after contracting HIV through a blood transfusion, was an AIDS advocate. Ashe died in 1993. This photograph is dated March 25, 1965. (Courtesy of Hollywood Citizen-News/Valley Times Collection/Los Angeles Public Library.)

The Los Angeles Lakers' Kareem Abdul-Jabbar slams in two points as the Detroit Pistons watch. The dominant center was known for his skyhook shot. Born Ferdinand Lewis Alcindor Jr., Abdul-Jabbar changed his name after converting to Islam. He played professional basketball for 20 seasons, most of them with the Lakers. His accomplishments, including world championships and scoring titles, place him among the elite players of all time. This photograph is dated February 14, 1989. (Courtesy of Herald-Examiner Collection/Los Angeles Public Library.)

Magic Johnson (second from left) leads Lakers teammates, from left to right, Billy Thompson, Mychal Thompson, Byron Scott, and James Worthy in an antidrug rap at Inglewood High School on April 9, 1987. The players, whose routine was choreographed by Worthy's wife, urged schoolchildren at an assembly to refuse drugs. It was the team's fourth-annual visit. The Lakers have traditionally been among the foremost boyhood heroes of Angelinos of all colors. (Courtesy of Herald-Examiner Collection/ Los Angeles Public Library.)

On November 22, 1987, Bo Jackson speaks to reporters. Jackson was the first athlete to be named an All-Star in both the NFL and MLB. He was a running back for the Los Angeles Raiders and left fielder for various baseball teams, including the Kansas City Royals and Chicago White Sox. He became recognized through his "Bo Knows" campaign for Nike. (Courtesy of Herald-Examiner Collection/ Los Angeles Public Library.)

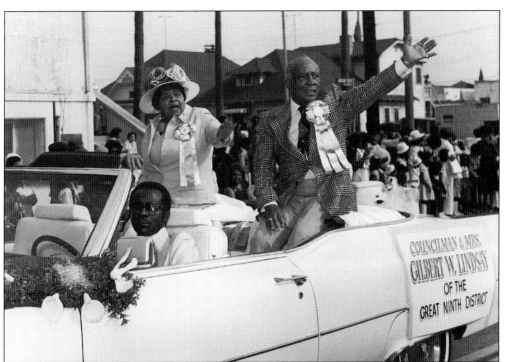

Los Angeles councilman Gilbert W. Lindsay and his wife, Ann Lindsay, ride in a car during a parade. Born in Mississippi, Lindsay moved to Los Angeles after serving in the army. He became a janitor in the city's Department of Water and Power and was elected to the city council in 1963, serving for nearly 30 years. He was known as the "Emperor of the Great Ninth District." (Institute for Arts and Media, Guy Crowder Collection, CSUN.)

Nate Holden (left) is seen here with Mayor Kenneth Hahn. Holden, a former design engineer in the aerospace industry, became county supervisor Hahn's chief deputy. Since then, Holden has spent decades as a public servant: California State Senator from 1974 to 1978, then a Los Angeles city councilman from 1987 to 2003. (Institute for Arts and Media, Guy Crowder Collection, CSUN.)

Civil rights icon Rosa Parks (center) was honored at a dinner hosted by the Black Women's Forum in 1979. She was accompanied by actress, television icon, entrepreneur, and philanthropist Oprah Winfrey (left) as well as Rep. Maxine Waters (right). Rosa Parks was the catalyst for the Montgomery, Alabama, bus boycott in the 1950s, which galvanized support to break down southern segregation of bus lines and led very directly to the civil rights movement. The City of Los Angeles named a section of the I-110 freeway in her honor in 2002. (Courtesy of the Institute for Arts and Media, Guy Crowder Collection, CSUN.)

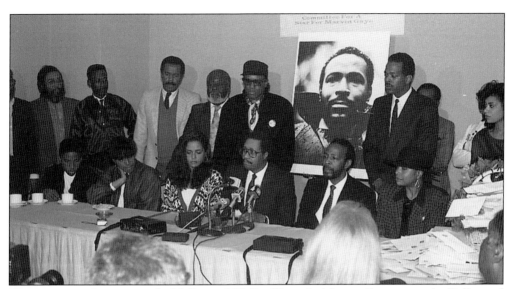

The committee for a star on the Hollywood Walk of Fame for Marvin Gaye met at the Hollywood Roosevelt Hotel on December 1, 1989. Members of the committee included family and friends. Gaye was part of the doo-wop group the Moonglows, which signed with the Motown Records label in 1961. Subsequently, Gaye ranked as the label's top-selling solo artist during the 1960s. On April 1, 1984, he was shot and killed by his father in Los Angeles. The famous son was only 44. His star, number 1084, was unveiled on September 27, 1990, at 1504 Vine Street. (Courtesy of the Institute for Arts and Media, Guy Crowder Collection, CSUN.)

Actress and community activist Marla Gibbs receives an Essence Award in 1987 at the Biltmore Hotel. Originally from Chicago, the star is best known for her role as the sarcastic maid Florence Johnston on *The Jeffersons* and for her starring role as Mary Jenkins on *227*. Gibbs has contributed to the arts in Los Angeles, performing in local theater and studying with her daughter Angela at the Mafundi Institute and Watts Writers Workshop. Gibbs also formerly owned the Vision Theatre. She is shown here with *227* costar Hal Williams. (Courtesy of the Institute for Arts and Media, Guy Crowder Collection, CSUN.)

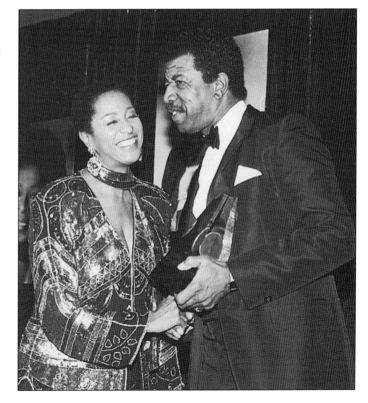

At age 5, Orvin Wilson poses for his family portrait in 1989. The Wilson family spent the day at a Leimert Park studio for this family photograph shoot. Originally from Jamaica, the Wilsons moved to Los Angeles in 1987. Orvin graduated from King Drew High School in 2002. (Courtesy of Orvin Wilson.)

Taken on Easter Day 1986, this photograph is representative of Easter fashions among African American families. It is not uncommon for African American families to purchase sharp new outfits for church. From left to right, Jasmin Young, Glenn Young, and Joseph Young are shown sporting their lovely Easter attire after a day at church. (Courtesy of Jasmin Young.)

Seven

SOCIAL UNREST, SOCIAL CHANGE

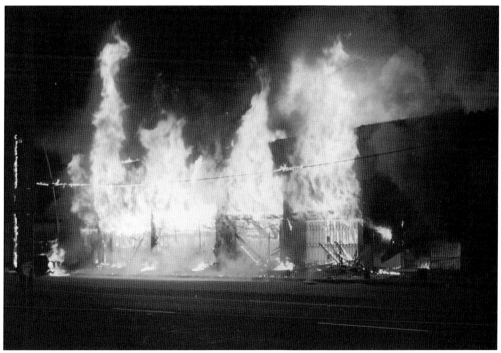

On March 3, 1991, Rodney King and two passengers were driving west on the Foothill Freeway in Los Angeles's San Fernando Valley. After a high-speed chase, King was Tasered and beaten by four members of the LAPD. The beating was captured on video that was seen on television news reports worldwide, and the four officers faced felony charges. On April 29, 1992, a jury found all officers not guilty on all charges of assaulting King and acquitted three of excessive force charges, with the fourth having a hung jury. Extensive televised coverage of the trial's verdicts ignited a violent reaction that spread quickly across Los Angeles County. For six days, Los Angeles burned in more ways than one. (Courtesy of the Institute for Arts and Media, Guy Crowder Collection, CSUN.)

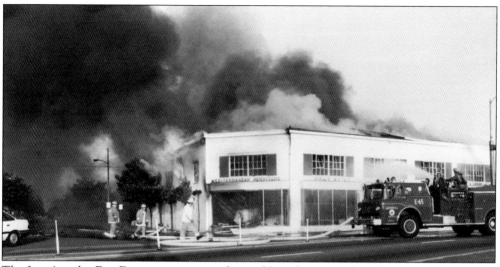

The Los Angeles Fire Department responds to a blaze destroying local businesses during the King-verdict riots. Mayor Tom Bradley imposed a curfew, and schools and businesses closed. Four thousand National Guard troops, 2,000 U.S. Army troops, 1,500 Marines, and 300 California Highway Patrol officers were sent to suppress the rebellion, along with the LAPD, the sheriff's department, and other local law enforcement agencies. Fifty-five people were killed, more than 4,000 were injured, and 12,000 were arrested. Damage totaled approximately $1 billion. (Courtesy of the Institute for Arts and Media, Guy Crowder Collection, CSUN.)

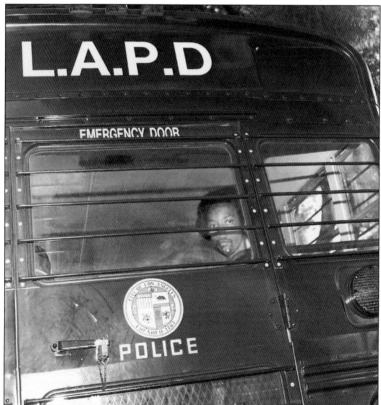

Unfortunately, this is an all too familiar scene of a black male being driven away from his family to a police station. This photograph was taken in September 1996. (Courtesy of Southern California Library.)

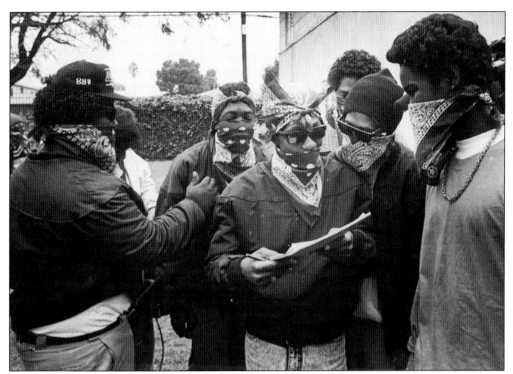

On November 15, 1988, members of the Eighty-eighth Street Avalon Crips gang gather to sign a peace treaty to stop gang violence. Community leaders saw the agreement as an important step to resolving some of the hardships for the residents of South Central. (Courtesy of Herald-Examiner Collection/Los Angeles Public Library.)

James Nathaniel "Jim" Brown, born February 17, 1936, on St. Simon's Island, Georgia, is a former NFL running back and the star of numerous action movies. He is best known for his record-setting career with the Cleveland Browns from 1957 to 1965. In 2002, he was named by *Sporting News* as the greatest professional football player ever. In 1988, longtime Los Angeles resident Brown founded Amer-I-Can, a gang intervention and life skills program operating in inner cities and prisons. (Courtesy of Herald-Examiner Collection/Los Angeles Public Library.)

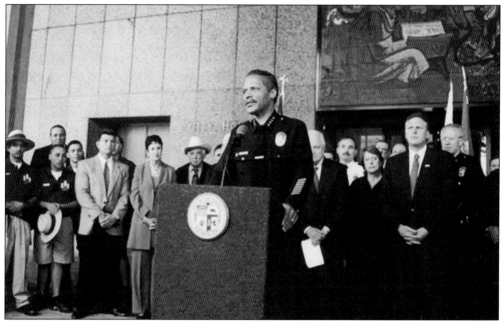

Bernard C. Parks (center) was appointed chief of the LAPD on August 12, 1997, the second African American police chief in Los Angeles. Parks served on the force for 38 years, and his term as chief ended in 2002. In 2003, he became a member of the Los Angeles City Council, representing the Eighth District, which includes the Baldwin Hills, Crenshaw, Leimert Park, and West Adams areas. Parks received his Bachelor of Science from Pepperdine University and his Master of Public Administration from USC. (Courtesy of Los Angeles Public Library.)

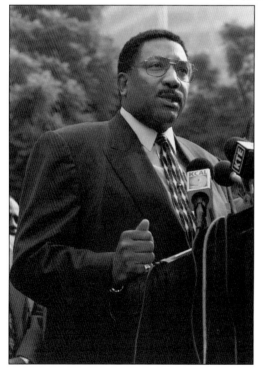

Willie L. Williams (born October 1, 1943) was chief of the LAPD from 1992 to 1997, taking over after the resignation of Chief Daryl Gates following the 1992 riots. Born in Philadelphia, Williams served as commissioner of his home town's police department before moving to Los Angeles. Though he received high marks for restoring public confidence, members of the Police Commission criticized Williams for poor leadership skills and management style. He also failed to garner support from rank-and-file LAPD officers. (Courtesy of Southern California Library.)

Vernon Hayes (left) and Jason Whitlock pose for a photograph in 2004 while leaning on a car in the West Athens area, an unincorporated community of Los Angeles County. The style of oversized pants and shirts with white, no-scuff athletic shoes was typical for young African American males growing up in South Los Angeles. (Courtesy of Connie V. Whitlock.)

Diane Watson (right) joins Mayor Richard Riordan (left) and future mayor Antonio Villaraigosa (third from left) at the inaugural ceremony of councilman Bill Rosendahl (second from left), held at Venice Beach on July 2, 2005. Watson served the public in many arenas, including on the board of the Los Angeles Unified School District, as a member of the California State Senate, and as U.S. Ambassador to Micronesia. In 2001, she was elected as a U.S. Representative for the 33rd Congressional District in California. (Courtesy of Gary Leonard.)

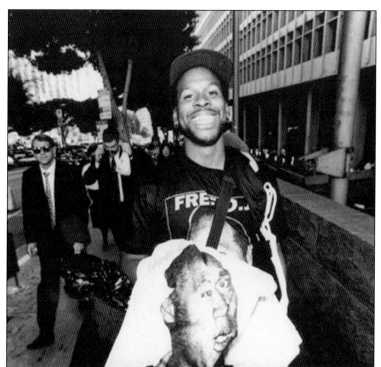

Actor and NFL Hall of Famer Orenthal James "O. J." Simpson stood trial for the murder of his ex-wife, Nicole Brown Simpson, and her friend Ronald Goldman in 1995. The trial became the focus of much media and community attention nationwide. Here an unidentified young African American vendor stands in front of the Criminal Courts Building wearing a T-shirt with the slogan "Free O. J." (Courtesy of Los Angeles Public Library.)

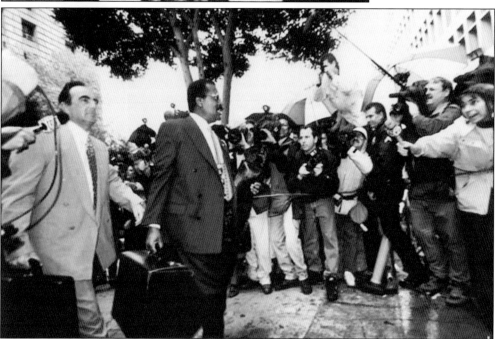

With an all-star "Dream Team" of defense lawyers led by African American Johnnie L. Cochran Jr., the O. J. Simpson murder trial has been described as the most publicized criminal trial in American history. Two of Simpson's attorneys—Robert Shapiro (left) and Johnnie Cochran (right)—are shown entering the Criminal Courts Building. Simpson was acquitted of all charges. (Courtesy of Los Angeles Public Library.)

John Hope Bryant founded Operation HOPE, Inc. immediately following the 1992 Rodney King rebellion in Los Angeles. Operation HOPE is a nonprofit social investment banking organization and self-help provider of economic empowerment tools and services for underserved communities. Bryant also became vice-chairperson of the U.S. President's Advisory Council on Financial Literacy and chairperson of the council's Under-Served Committee. Bryant was born in Los Angeles and raised primarily in Compton and South Central. (Courtesy of Operation HOPE.)

Blair Hamilton Taylor is the president and chief executive officer of the Los Angeles Urban League, an affiliate of one of the nation's leading civil rights organizations. Similar to the most recent civil rights leaders, Taylor has a background in entrepreneurship, having served as the president and CEO of a leading retail franchise. Urban League programs focus on mentoring, education, business services, and employment. (Courtesy of Los Angeles Urban League.)

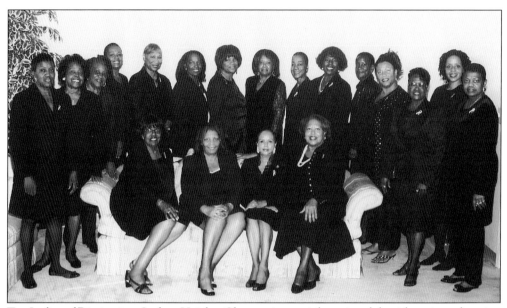

Top Ladies of Distinction, Ladera Heights Chapter, is a social service club with projects focusing on scholarships, senior citizens, the status of women, community beautification, and community partnerships. The group's service projects have earned them national recognition, with three members named top ladies of the year by the national organization. (Courtesy of Alna Brown.)

In 2004, Karen Bass was elected to represent the 47th District in the California State Assembly. In 2008, she became the first black woman speaker of any state assembly in the country. A longtime community activist and physician's assistant, Bass founded the Community Coalition for Substance Abuse Prevention and Treatment in 1990. (Courtesy of Karen Bass.)

Eight

A NEW GENERATION

The Leimert Theatre opened in 1931 as a neighborhood movie house, serving the Crenshaw district for many decades. A building with a history of varied uses, the theater was converted into a church by Jehovah's Witnesses in 1977, and in 1990, popular actress and neighborhood activist Marla Gibbs purchased the venue and named it the Vision Center. Her personal vision revitalized the theater and neighborhood, as patrons attended a wide variety of performances. In 1999, the Vision Theatre was purchased by the City of Los Angeles Department of Cultural Affairs, which utilizes it as a community performance center. (Courtesy of Estella Owoimaha.)

The first of the Magic Johnson Theatres opened at the Baldwin Hills–Crenshaw Plaza Mall in the heart of the African American community in 1995. The 12-screen movie complex was part of the business holdings of Naismith Memorial Basketball Hall of Fame member and "Showtime" Lakers legend Earvin "Magic" Johnson. The theater was part of his overall plan to encourage local economic growth in urban communities. (Courtesy of Estella Owoimaha.)

Eso Won Bookstore is located in the heart of Leimert Park on Degnan Boulevard. Eso Won caters to the African American community, carrying popular and out-of-print books related to African American life. Eso Won has hosted authors from presidents Barack Obama and Bill Clinton to actors such as comedian Bill Cosby. Eso Won translates to an African proverb meaning "water over rocks." (Courtesy of Estella Owoimaha.)

The *Mural of African American Progress* runs for a few blocks along Crenshaw Boulevard, near Fifty-second Street, through the center of the Crenshaw district. It portrays black history and is homage to the greatness of African American people. Abolitionist, statesman, and writer Frederick Douglass is depicted on the right. (Courtesy of Emebet Tesfahun.)

Randy's Donuts is a 24-hour drive-through located at 805 West Manchester Boulevard at La Cienega Boulevard in Inglewood. Built in 1953, Randy's features an unusually large donut on the roof, which has been highlighted in many movies, television shows, and music videos. A similar giant donut is found at Kindle's Donuts at Normandie Avenue and West Century Boulevard in Los Angeles. (Courtesy of Mark Hill.)

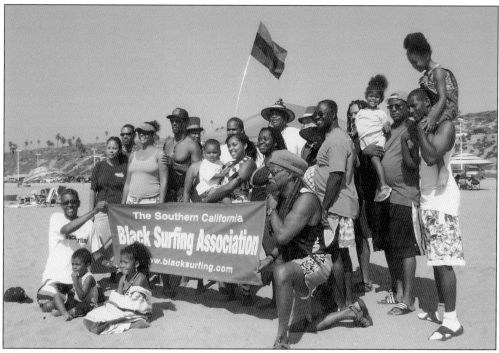

The Black Surfing Association, pictured here in 2009 at Dockweiler State Beach at the end of Imperial Highway, exists to "expand the sport and culture of wave riding among African people." The association refers to surfing as "wave dancing." Its creed states, "We are bonded together by two cosmic forces, blood and water. The blood being our ancestral African roots, and water being the oceans and seas of the world." (Courtesy of James Simmons.)

An unidentified vendor sells Barack Obama memorabilia on the Venice Beach Boardwalk. A major tourist attraction, Venice Beach is a haven for artists and craftsmen who sell their creations from tables, easels, and cloths spread on the ground. Venice is also the home of a long-standing black community that has become endangered in the 21st century due to rising property values and gentrification. (Courtesy of Chandra Whitaker.)

In sunny Los Angeles, skateboarding is a year-round street sport, which has ebbed and flowed in popularity throughout the decades. Although skateboarding is not normally associated with African Americans, it has always been a staple of African American youth culture. In this photograph, Justin Pendleton, age 19, performs a nose stall on a small ledge at a Culver City Skate Park. (Courtesy of Cory Pendleton.)

Biboye Niweigha, known as "B-Boy," showcases great upper body strength and balance while demonstrating a "one-arm handstand leg hook with a freeze." Break dancing requires great creativity, balance, flexibility, and rhythm to prevail against other b-boys and b-girls and crews. (Courtesy of B-Boy.)

Zaynab Bent-Mikail flies through the air during the long jump event as a member of the Quiet Fire Track Club. Zaynab has won numerous ribbons and awards in other track events, including sprints and relays. This photograph was taken in 2008, when Zaynab was 11 years old. (Courtesy of Stephanie Jones.)

Rukayah Bent-Mikail, Zaynab's sister, commonly runs the 400-meter, or "4 x 1," relay as a member of the coed Quiet Fire Track Club based in Los Angeles. Quiet Fire members range from ages 5 to 18. These young athletes are regulars at the Junior Olympics. Rukayah wears traditional African American braiding style with beads in this 2003 photograph. (Courtesy of Stephanie Jones.)

Yanay Philips, Britni Cardosa, Anayah Whisenant, and Oumunique Drake take on Class IV rapids on the Kern River, which drains into the Sierra Nevada Range in Central California. The Los Angeles natives are on spring break. They frequently gather with other friends to engage in adrenaline-pumping sports. (Courtesy of Britni Cardosa.)

At a Sunday martial arts training at Venice Beach in August 1989, instructor James Simmons (right) demonstrates flexibility with a crescent kick to the head of Wilson Smith. The training was for members and comrades of the South West African People's Organization (SWAPO) Support Committee, a group working towards the independence of Namibia from colonial occupation in Southwest Africa. (Courtesy of James Simmons.)

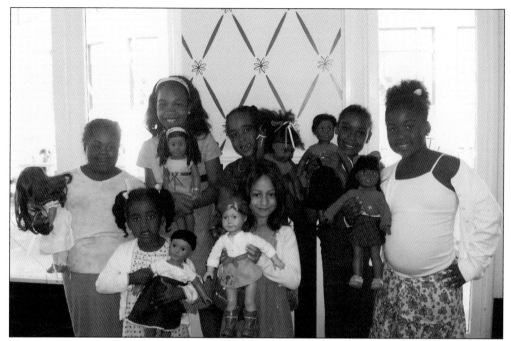

Young African American girls enjoy a friend's birthday party at the American Girl Place at the Grove Shopping Center in Los Angeles. American Girl Place stores are typically located in upscale communities. The girls are holding dolls with dark to light hues of skin, a giant leap from the days before the black pride movement of the 1960s, when primarily Caucasian dolls were manufactured. (Courtesy of Connie Whitlock.)

Sherrin Perkins relocated to Los Angeles from Louisiana after the devastation of Hurricane Katrina (2005). In Los Angeles, Perkins is a student and model. (Courtesy of Sherrin Perkins.)

Professor, columnist, and community activist Anthony Asadullah Samad is a former NAACP branch president for Los Angeles and the current president and chairman of the board of 100 Black Men of Los Angeles, Inc. Samad is well known as host of the Urban Issues Forum of Greater Los Angeles, a popular monthly public affairs forum that serves as an educational and news source on issues of concern to urban communities. (Courtesy of Anthony Samad.)

Mayme A. Clayton was born in Van Buren, Arkansas, and moved to Los Angeles in 1946. As a professional librarian, she worked at USC and UCLA. Throughout the years, Clayton collected rare books, documents, films, music, and photographs about African American life and culture. Upon her death at age 83 in 2003, Clayton's collection contained more than 20,000 pieces, making it the world's second-largest independent collection of African American memorabilia. It is housed at the Mayme A. Clayton Library and Museum in Culver City. (Courtesy of the Mayme A. Clayton Library and Museum.)

Featured in this photograph are college sweethearts turned husband and wife, Atnof and Jasmine Harris. This couple signifies young, upwardly mobile African American couples. The Harrises have now relocated to Fresno, where they will begin their family. Jasmine smiles as she flaunts her engagement ring. (Courtesy of Britni Cardosa.)

Estella Owoimaha (left) and Brandon Church, both natives of Los Angeles, grew up only a few blocks away from one another and never met until their young adult years. Dating since November 12, 2003, they decided to "jump the broom" and exchange marriage vows in 2010. Here they pose for an engagement photograph by David's Bridal photographers. (Courtesy of Estella Owoimaha and Brandon Church.)

Popular young singer and actress Keke Palmer (center) poses with fans Ashley Jackson (left) and Sophia White (right) at the Kids' Choice Awards in 2007. Palmer stars in the award-winning movie *Akeelah and the Bee* and in her own television comedy, *True Jackson, VP*. These beautiful girls at the awards show are evidence of another step in Hollywood's long road to diversity. (Courtesy of Ashley Jackson.)

In 2009, Malcolm Jamal Warner of *The Cosby Show* poses with, from left to right, Javanese Fuller, Marsha Wilson, and Jayme Alilaw at the third anniversary of Spoken Funk, where poets, comedians, and spoken word artists showcase their talents. (Courtesy of Marsha Wilson.)

Ashley Jackson (left) and the late pop icon Michael Jackson attend the Rainbow Push Coalition dinner and celebration of Rev. Jesse Jackson Sr.'s 66th birthday. At age 8, Ashley was elated at meeting one of the greatest entertainers of all time during the 2008 event at the Beverly Hilton Hotel. (Courtesy of Vanessa Hirsi.)

Dressed in splendid African attire, Osayande Ta'le-Sekani was on his way to the internationally recognized Pan African Film Festival at the Magic Johnson Theatre when he stopped to play the berimbau at the Capoeira Angola Roda. The Roda was held at Earlez Grill on Crenshaw Boulevard near Leimert Park. (Courtesy of James Simmons.)

On January 19, 2009, African Americans in Los Angeles and across the country celebrated both the inauguration of Barack Hussein Obama as the first African American president of the United States and the birthday of martyred symbol of change and nonviolence Dr. Martin Luther King Jr. In Dr. King's honor, the 24th anniversary of the Los Angeles Kingdom Day Parade traveled down Martin Luther King Jr. Boulevard from Western Avenue to Leimert Park Village. The theme of the parade was "The Dream Lives On for Today and Tomorrow." Participants included drill teams, a truck from the Service Employees International Union Local 721, the Egyptian Temple Five Mini Car Patrol, and a group of custom-bike riders. (Courtesy of Jasmin A. Young.)

It took 15 years to create the federal Martin Luther King Jr. holiday. Rep. John Conyers, Democrat from Michigan, first introduced legislation for a commemorative holiday four days after King was assassinated in 1968. After the bill became stalled, petitions endorsing the holiday with 6 million names were submitted to Congress. Throughout the decades, public pressure for the holiday mounted, particularly during the 1982 and 1983 civil rights marches in Washington, D.C. A compromise moving the holiday from January 15, King's birthday, which was considered too close to Christmas and New Year's, to the third Monday in January helped overcome opposition. Congress passed the legislation in 1983, and it was signed into law by Pres. Ronald Reagan. Shown here are participants in the parade. (Both, courtesy of Jasmin A. Young.)

Michelle Hartzog graduates with a degree in sociology from California State University, Northridge. This photograph was taken after the black graduation ceremony in 2007. Hartzog's proud mother, Dawn Williamson, poses with her. Hartzog later received a Master of Arts degree from the University of Chicago. (Courtesy of Michelle Hartzog.)

DISCOVER THOUSANDS OF LOCAL HISTORY BOOKS FEATURING MILLIONS OF VINTAGE IMAGES

Arcadia Publishing, the leading local history publisher in the United States, is committed to making history accessible and meaningful through publishing books that celebrate and preserve the heritage of America's people and places.

Find more books like this at
www.arcadiapublishing.com

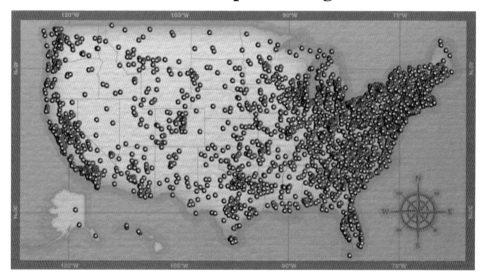

Search for your hometown history, your old stomping grounds, and even your favorite sports team.

Consistent with our mission to preserve history on a local level, this book was printed in South Carolina on American-made paper and manufactured entirely in the United States. Products carrying the accredited Forest Stewardship Council (FSC) label are printed on 100 percent FSC-certified paper.

MADE IN THE USA